THE BEST NEW
ANIMATION DESIGN 2

Selected by Rita Street

Rockport Publishers
Gloucester, Massachusetts
Distributed by North Light Books
Cincinnati, Ohio

First published in the
United States of America by:

Rockport Publishers, Inc.
33 Commercial Street
Gloucester, Massachusetts
01930-5089
Telephone: (508) 282-9590
Fax: (508) 283-2742

Distributed to the book
trade and art trade in
the United States by:

North Light Books, an imprint of
F & W Publications
1507 Dana Avenue
Cincinnati, Ohio 45207
Telephone: (800) 289-0963

Other Distribution by:

Rockport Publishers, Inc.
Gloucester, Massachusetts
01930-5089

ISBN 1-56496-355-1

10 9 8 7 6 5 4 3 2 1

Designer
The Design Company

Cover Image
Orbit Software Demo for software
developer Microsoft Softimage Inc.
(pages 152-153)

Manufactured in China

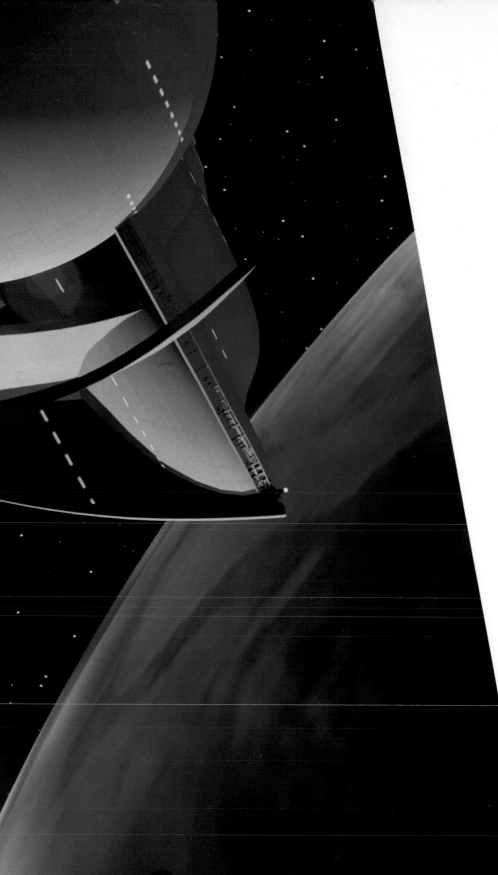

Contents

- Introduction 6

◖ Commercials 8

◖ Films 52

◖ Television 81

◖ Games 96

◖ Student Work 122

◖ Miscellaneous 130

- Directory 158

- Index 160

The art and industry of computer animation has evolved by leaps and bounds. Twenty-five short years ago the idea that the computer could generate images moving in sequence was just a glimmer in the eyes and minds of a few adventurous programmers. Today hardly a commercial or movie is made that doesn't incorporate a visual effect implementing this fascinating process.

When scientists and engineers first tried to produce simple graphics that either changed shape or moved across the screen, it took computers the size of cars working round the clock to accomplish the task. Quicker than any futurist could predict, these dinosaurs gave way to desktop counterparts capable of rendering complex frames in a fraction of the time.

Then, with the advent of the sub-micron transistor in the late '80s, hardware efficiency increased dramatically causing a simultaneous drop in hardware cost. Suddenly a single computer could perform the tasks of many. And, as hardware efficiency increased, so did the productivity of animation software. By the early '90s artists were able to animate in "real time," create photo-realistic characters, or actually produce — within a reasonable time span and budget — a completely computer animated feature.

However, computer animation had a stigma riding its digital shoulders. Audiences, who for years were bombarded with metallic flying logos and block shaped robotic humans, felt that the medium produced only "cold" characters and unbelievable worlds. Even though computer animators knew they were capable of creating work that was both believable and "warm," audiences did not share their optimism — at least not until a pull string cowboy named Woody and a hi-tech toy called Buzz wiggled their way into the hearts of millions.

> "Twenty-five short years ago the idea that the computer could generate images moving in sequence was just a glimmer in the eyes and minds of a few adventurous programmers."

With the Walt Disney release of Pixar's "Toy Story" computer animation came into its own. Suddenly audiences couldn't get enough of engaging characters made from combinations of 1s and 0s. Hollywood jumped aboard the production wagon and began pressing the computer industry for more blockbusters, several of which will hit the silver screen by the turn of the century.

But, it is not only the big players with lightning fast workstations and proprietary animation systems that are making waves in computer animation today. Because software developers are now releasing Windows NT versions of their previously "UNIX only" applications, it is now economically viable for small studios to purchase high quality applications and run them on their PCs. As you'll see within the pages of this showcase, it's becoming harder and harder to tell the work of a boutique house in Kansas from a mega-shop in Silicon Valley. Success in computer animation is now measured less by a company's capital investment and engineering prowess than by its ability to attract the cream of the artistic crop.

Which points to the most important element in computer animation production today — people. It is not technology that makes the industry shine. It is people — animators, artists, and engineers. This showcase is dedicated to them — to their ability to create worlds most of us could only imagine and to their innovative use of a very fine tool — the computer. ◈

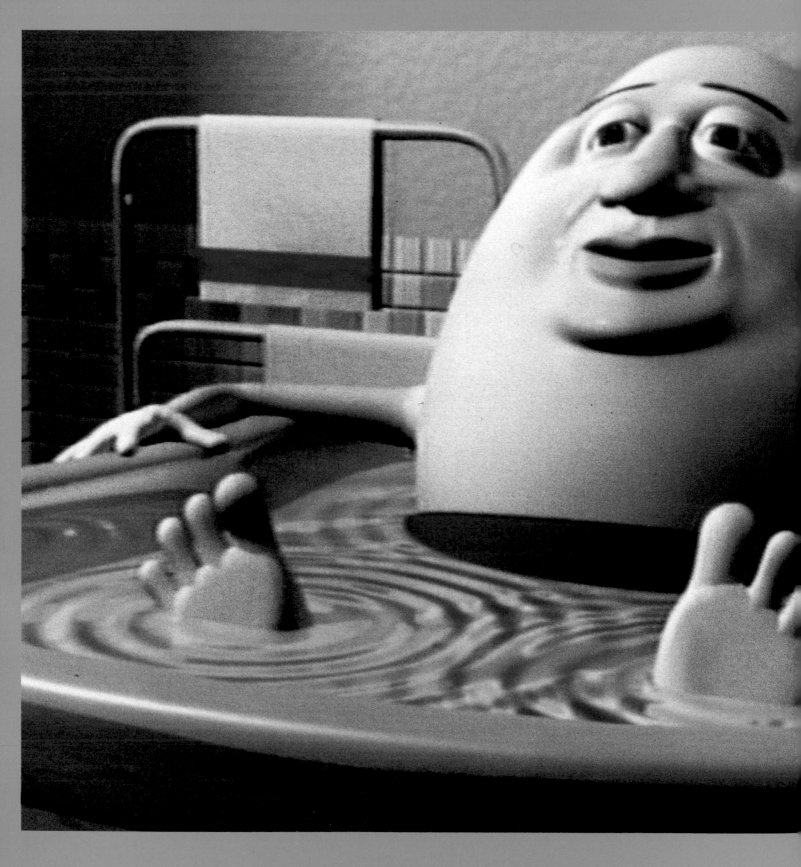

C O M M E R C I A

S

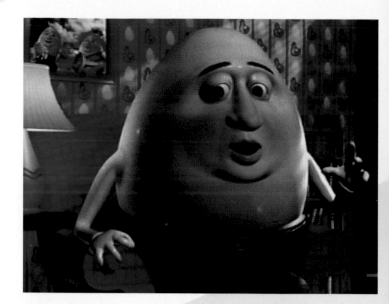

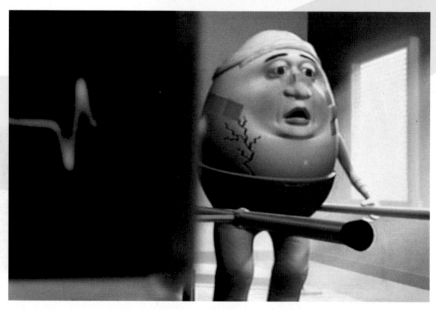

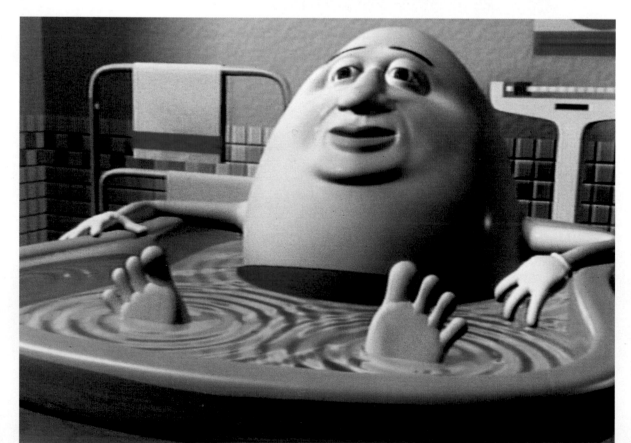

HUMPTY

Animation Studio
Curious Pictures

Client/Agency
North Kansas City Hospital/
Muller & Co.

Character Creators/Designers
Mike Defeo, Tom Cushwa

Supervising Animator
Tom Cushwa

Technical Director/Director
Steve Katz

Producer
Anezka Sebak

Software Used
Alias/Wavefront PowerAnimator

Hardware Used
Silicon Graphics, Inc.

Original character sketches were
created on paper and sculpted in cl
This was used as the model for 3-D
NURBS (Non-Uniformed B-splines)
Lip synch was done using Alias
technology facial expressions. All
rendering was done using Alias'
native renderer.

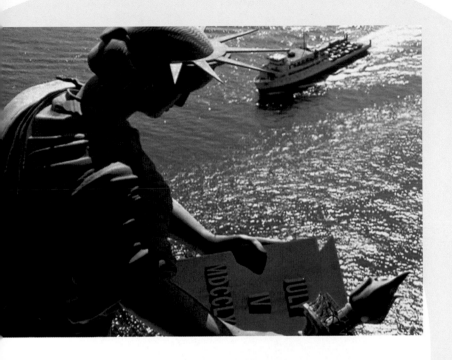

OLDSMOBILE AURORA
CAUGHT THEIR EYE

Animation Studio
R/Greenberg Associates

Client/Agency
Oldsmobile/Leo Burnett
Company, Inc.

Computer Graphics Animators
Eileen O'Neill, David Barosin,
Jason Strougo, Jim Hundertmark,
Steve Blakey, John Musumeci

Technical Director
Henry Kaufman

Visual Effects Supervisor
Ed Manning

Director of Computer Graphics
Mark Voelpel

Software Used
Microsoft Softimage, R/GA
proprietary software

Hardware Used
Silicon Graphics, Inc.

To recreate a realistic image, they
began by filming a woman dressed
as the statue walking through a
2,000 gallon tank and holding a
miniature of the Aurora. This was
followed by an on-location shoot in
New York Harbor. R/GA created
three-dimensional computer models
of the statue, her robe, and torch for
a total of 31 shots. R/GA finished the
commercial by compositing the
computer-generated and live-action
images via its component D-1
digital video.

Oldsmobile Aurora "Caught Their Eye" ©
1996 The Oldsmobile Division of General
Motors Corporation courtesy of R/Greenberg
Associates, N.Y. and Leo Burnett Company, Inc.

11

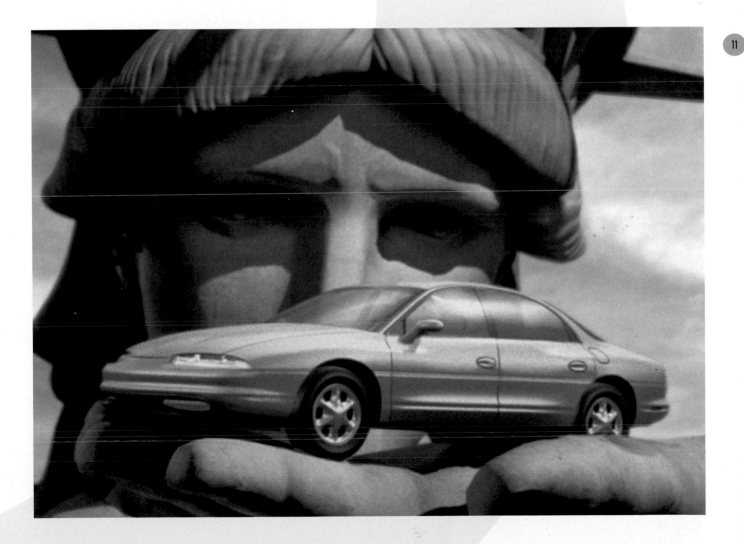

WILD FRIJOLES

Animation Studio
Pixar

Client/Agency
Hunt-Wesson, Inc./
Ketchum Advertising

Character Creators/Designers
Andrew Schmidt, Ron Lim

Animators
Alan Sperling, Warren Trezevant,
Jimmy Hayward, Dave Tart,
Steve Segal

Technical Director
Larry Aupperle

Animation Director
Andrew Schmidt

Creative Director
Jill Murray

Art Director
Ron Lim

Producer
James Horner

Software Used
Pixar Marionette

The commercial begins in a sleepy, dusty western town where the tortilla chip inhabitants are snoozing during their afternoon siesta. The sleepy town is suddenly awakened by the gang, "The Beanditos," who bring fun to the town and liven up dinner plates. It was rendered using Pixar's rendering systems, implementing the RenderMan® Interface for 3-D scene description, employing such techniques as procedural shading and texturing, self-shadowing, motion blur, and texture mapping.

©Hunt-Wesson, Inc. 1996

12

WHERE WORLD PREMIERE TOONS COME FROM

Animation Studio
Serious Robots Animation

Client/Agency
The Cartoon Network

Lead Animator
Jim Regan

Art Director
Nancy Rich

Writer/Producer
Scott Lipe

Software Used
Alias/Wavefront PowerAnimator,
Discreet Logic Flint

Hardware Used
Silicon Graphics, Inc.

The scenes were rendered at 24
frames per second and converted to
30 fps to give that film-transfer look.
Discreet Logic Flint software was
used to composite and color correct,
and also to add simple 2-D elements.
Motion-blur was also incorporated
into the fast-paced promotional spot.

SHELL OIL DANCE FEVER

Animation Studio
R/Greenberg Associates

Client/Agency
Ogilvy & Mather, Houston

Computer Graphics Animators
Fred Nilsson, Steve Blakey, Edip Agi

Technical Director
Sylvain Moreau

Computer Graphics Director
Mark Voelpel

Computer Graphics Designer
Sylvain Moreau

Software Used
Microsoft Softimage, R/GA
proprietary software, Imrender

Hardware Used
Silicon Graphics, Inc.

R/GA and director David Lane of Savoy
Commercials used dancers for visual
reference. A playful interpretation of
human dance motion was constructed
entirely in computer graphics on Silicon
Graphics workstations, using 3-D mod-
els from Viewpoint DataLabs; Microsoft
Softimage 3-D; and Imrender, R/GA's
proprietary software.

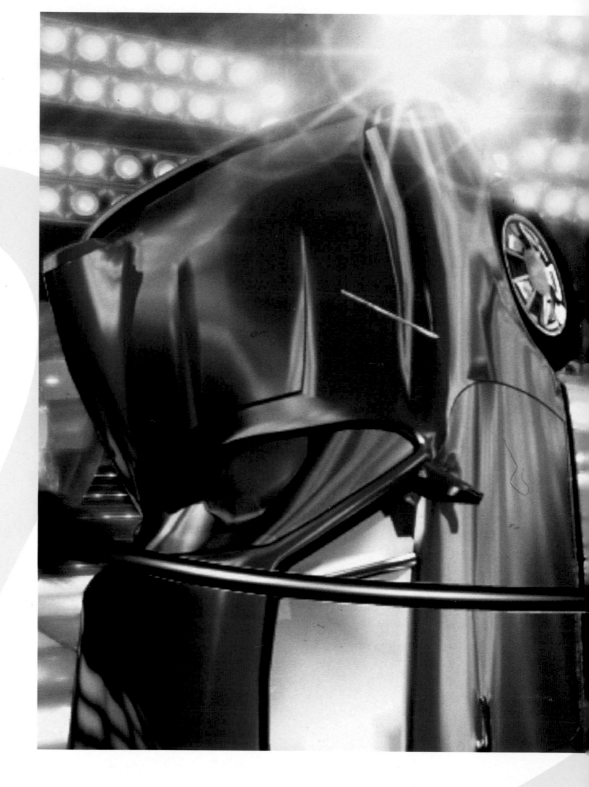

SHELL OIL CHICAGO BLUES

Animation Studio
R/Greenberg Associates

Client/Agency
Ogilvy & Mather, Houston

Computer Graphics Animators
Doug Johnson, Sean Curran,
Steve Mead, Fred Nilsson, Steve
Blakey, Edip Agi

Technical Director
Sylvain Moreau

Computer Graphics Director
Mark Voelpel

Computer Graphics Designers
Sylvain Moreau, Irene Kim

Software Used
Microsoft Softimage, R/GA
Proprietary Software, Imrender

Hardware Used
Silicon Graphics, Inc.

The creators used dancers for visual reference, from which the motion was constructed entirely in computer graphics. Miniatures were created and then married in R/GA's D-1 component digital video suite. R/GA's special effects editors created a seamless composite of 220 separate layers in the final composite.

"Chicago Blues" :30, ©Shell Oil 1995.
Courtesy of R/Greenberg Associates, N.Y. and
Ogilvy & Mather, Houston.

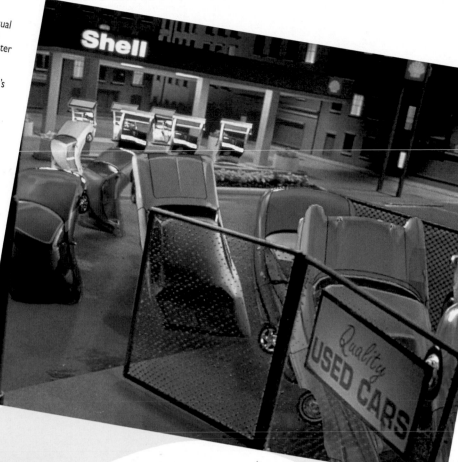

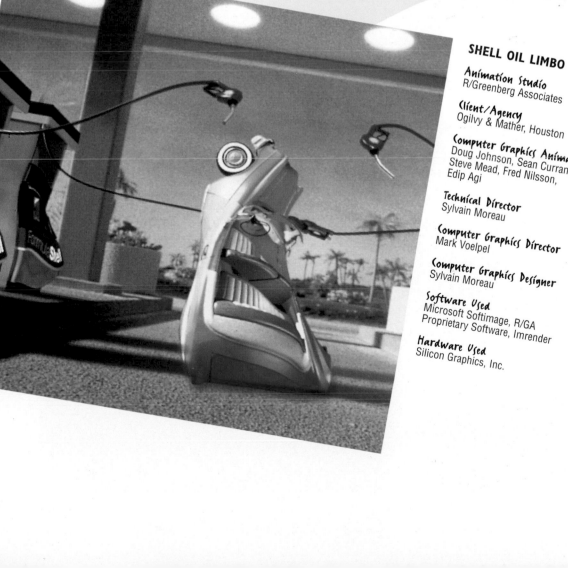

SHELL OIL LIMBO

Animation Studio
R/Greenberg Associates

Client/Agency
Ogilvy & Mather, Houston

Computer Graphics Animators
Doug Johnson, Sean Curran,
Steve Mead, Fred Nilsson,
Edip Agi

Technical Director
Sylvain Moreau

Computer Graphics Director
Mark Voelpel

Computer Graphics Designer
Sylvain Moreau

Software Used
Microsoft Softimage, R/GA
Proprietary Software, Imrender

Hardware Used
Silicon Graphics, Inc.

The motion of the vehicles was created in computer graphics, but dancers were used for reference. The final composite consisted of 220 layers combined by R/GA's special effects editors.

"Limbo" :30, ©Shell Oil 1995. Courtesy
of R/Greenberg Associates, N.Y.
and Ogilvy & Mather, Houston.

SPONGE IMPERSONATOR

Animation Studio
Curious Pictures

Client/Agency
3M/Grey Advertising

Character Creator/Designer
Ian Christie

Supervisor/Animator
Ian Christie

Technical Director
Steve Katz

Director
Steve Oakes

Producer
Russ Dubé

Software Used
Alias/Wavefront PowerAnimator,
Adobe After Effects

Hardware Used
Silicon Graphics, Inc.
Indigo Extreme II

The challenge in creating the sponge
character was in developing the
fibrous texture of the 3M sponge
product. This was accomplished by
using a combination of texture mapping
and 3-D geometry by using Alias'
NURBS modeler. Atmospheric effects
were created by using Alias' particle
system. Final compositing was done
by using Adobe After Effects.

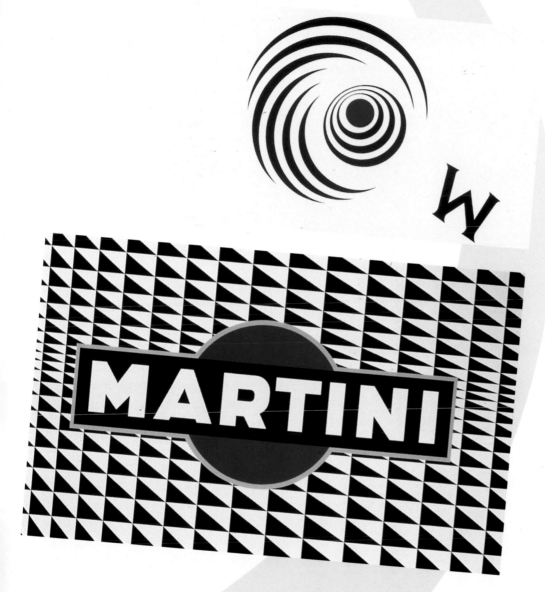

COMPOSITION IN OP

Animation Studio
Curious Pictures

Client/Agency
Martini & Rossi/Amster Yard

Character Creator/Designer
Mike Bade

Supervisor/Animator
Harold Moss

Technical Director
Steve Katz

Director
Ellen Kahn

Producer
Meredith Brown

Software Used
Adobe After Effects and Illustrator

Hardware Used
Macintosh

The creators started in Illustrator, creating individual shapes and backgrounds. Shape animations were done in Illustrator and composited into large background animations. The bottle and squiggle line animation were done by hand and duplicated digitally.

©1996 Bacardi/Martini

17

ROCK 'N' ROLL

Animation Studio
Curious Pictures

Client/Agency
Labatt's Beer/PNMB/Publitel

Character Creator/Designer
Kent Yu

Supervisor/Animators
Kent Yu, Ian Christie

Technical Director
Steve Katz

Director
Steve Oakes

Producer
Russ Dubé

Software Used
Alias/Wavefront PowerAnimator,
Adobe After Effects

Hardware Used
Silicon Graphics, Inc.

Live background images from the
Florida shoot were digitized and
brought into 3-D Studio for
pre-visualization. Once the entire
spot was templated, each shot was
recreated in Alias/Wavefront
PowerAnimator. Final shots were
composited in Adobe After Effects.

STAND OFF

Animation Studio
Olive Jar Studios

Client/Agency
The Southland Corporation,
J. Walter Thompson (Chicago)

Creative Director
Fred MacDonald

Supervising Animator
Rich Ferguson-Hull

Technical Director
Bryan Papciak

Directors
Fred MacDonald, Rich Ferguson-Hull, Bryan Papciak

Producer
Jim Moran

Executive Producer
Matthew Charde

Software Used
Quantel Henry

SNOWBOUND

Animation Studio
Olive Jar Studios

Client/Agency
The Southland Corporation,
J. Walter Thompson (Chicago)

Creative Director
Fred MacDonald

Supervising Animator
Rich Ferguson-Hull

Technical Director
Bryan Papciak

Directors
Fred MacDonald, Rich Ferguson-
Hull, Bryan Papciak

Producer
Jim Moran

Executive Producer
Matthew Charde

Hardware Used
Quantel Henry

21

THE BIRDS

Animation Studio
Olive Jar Studios

Client/Agency
The Southland Corporation,
J. Walter Thompson (Chicago)

Creative Director
Fred MacDonald

Supervising Animator
Rich Ferguson-Hull

Technical Director
Bryan Papciak

Directors
Fred MacDonald, Rich
Ferguson-Hull, Bryan Papciak

Producer
Jim Moran

Executive Producer
Matthew Charde

Hardware Used
Quantel Henry

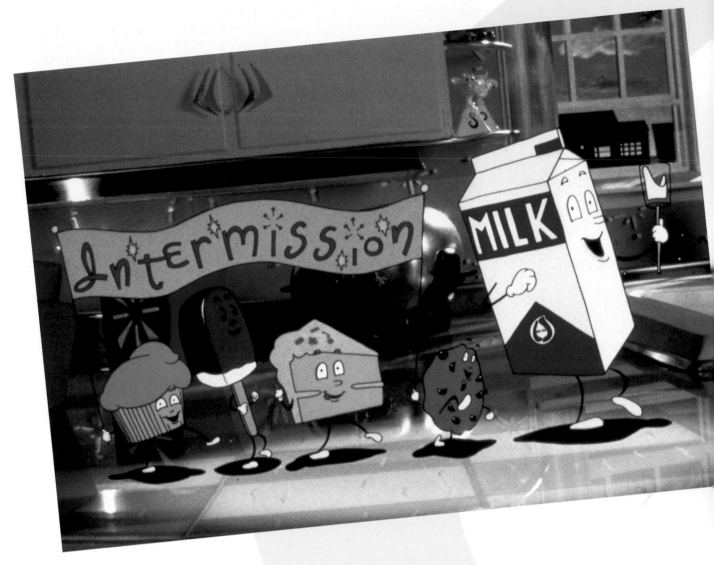

INTERMISSION

Animation Studio
Olive Jar Studios

Client/Agency
Dairy Management, Inc.,
J. Walter Thompson (Chicago)

Creative Director
Fred MacDonald

Supervising Animator
Rich Ferguson-Hull

Technical Director
Bryan Papciak

Director
Fred MacDonald,
Rich Ferguson-Hull

Executive Producer
Matthew Charde

Hardware Used
Discreet Logic Flame,
Quantel Henry

SKATERS

Animation Studio
Blue Sky Studios, Inc.

Client/Agency
Clamato, J. Walter Thompson, NY

Character Creator/Designer
Chris Wedge

Supervisor/Animators
Chris Wedge, John Kahrs

Technical Director
Chris Trimble

Director
Chris Wedge

Other Personnel
Nina Rappaport

Software Used
Microsoft Softimage, CGI Studio™,
Alias/Wavefront PowerAnimator

Hardware Used
Silicon Graphics, Inc.
HP Apollo

23

In the thirty-second spot, the glasses perform an intricate routine, CGI ice-chips fly, and paparazzi flash bulbs erupt from the audience. To keep the glasses from appearing rubbery, they bend only when necessary, preserving the material properties of the glasses. Director Chris Wedge researched live-action skating footage to choreograph the Clamato on ice fantasy.

©1995 Cadbury Beverages, Inc.

24

ABC NEWS SHOW CLOSE

Animation Studio
Blue Sky Studios, Inc.

Client/Agency
ABC News

Character Creator/Designer
John Kahrs

Supervisor/Animator
Steve Talkowski

Technical Directors
Clifford Bohm, Lutz Muller

Director
John Kahrs

Producers
Christopher Scollard,
Cindy Brolsma

Software Used
Microsoft Softimage, CGI Studio™,
Alias/Wavefront PowerAnimator

Hardware Used
Silicon Graphics, Inc.,
HP Apollo

©ABC News

BIG CLOCK

Animation Studio
Blue Sky Studios, Inc.

Client/Agency
Shell Oil, Promotional Campaigns
(Houston, TX)

Character Creator/Designer
Mark Baldo

Supervisor/Animators
Steve Talkowski, Jim Bresnahan,
Tom Bisogno

Technical Directors
Rhett Collier, Lutz Muller,
Hilmar Koch

Digital Painter
Linda Caldwell

Director
Mark Baldo

Producers
Carol Laufer, Chris Scollard

Software Used
Microsoft Softimage, CGI Studio™,
Alias/Wavefront PowerAnimator

Hardware Used
Silicon Graphics, Inc., HP Apollo

The commercial was animated in
Microsoft Softimage and rendered in
Blue Sky's proprietary software CGI
Studio™.

©Shell Mastercard 1995

TANGO

Animation Studio
Blue Sky Studios, Inc.

Client/Agency
Post, Grey Advertising, N.Y.

Character Creator/Designer
Mark Baldo

Supervisor/Animators
Jim Bresnahan, Ed Gavin,
Doug Dooley

Technical Directors
Lutz Muller, Rhett Bennatt,
Thane Hawkins

Director
Mark Baldo

Producer
Harry Stoiber, Carol Laufer

Software Used
Microsoft Softimage, CGI Studio™,
Alias/Wavefront PowerAnimator

Hardware Used
Silicon Graphics, Inc.,
HP Apollo

© 1996 Kraft

DIFFERENT DRUMMER

Design and Editorial Company
Two Headed Monster

Production Company
Smillie Films

Client
Tele-Communications, Inc.

Agency
Red Ball Tiger, San Francisco

Art Director/Designer
David J. Hwang

Live Action Director
Peter Smillie

Editor
Christopher Willoughby

Executive Producer
Ruth Schiller

Design Assistant
Treena Loria

Red Ball Tiger Producer
Carey Crosby

Software Used
Henry, Adobe Photoshop and Illustrator

Hardware Used
Power Mac, Silicon Graphics, Inc., Indigo 2 and Onyx

27

28

PHYSICS

Design/Editorial Company
Two Headed Monster

Client
Team Lucky Strike Suzuki

Agency
Bates, NY, USA

Designer/Director
David J. Hwang

Technical Director
David J. Hwang

Editor
Christopher Willoughby

Executive Producer
Ruth Schiller

Assistant Designer
Dana Walbaum

Art Director
Victor Mazzeo (Bates, USA)

Software Used
Flint, Henry, Adobe Photoshop
and Illustrator, Color Studio

Hardware Used
Power Mac, Silicon Graphics, Inc.,
Indigo 2 and Onyx

Designer David Hwang utilized
traditional cel animation, along
with Photoshop, Illustrator, and
Color Studio, to create textures,
hand-rendered type, and scientific
illustrations. Motorcycle racing stock
footage was imported and doctored
by defining perspective, elongating
and cropping frames, boosting
contrast, and manipulating the
color palette.

DOLPHINS CHECKS

Animation Studio
DESIGNefx

Client/Agency
First Union Bank, WM.
Cook Agency

Character Creator/Designer
Darlene Hadrika

Supervisor/Animators
Norman Craft, Jon Kemp,
Brett Gardy

Director
Steve Walker

Software Used
Alias/Wavefront PowerAnimator,
Proprietary (Norman Craft)

Hardware Used
Silicon Graphics, Inc.

30

PIZZA STEAM

Animation Studio
DESIGNefx

Client/Agency
Coca-Cola Company

Character Creator/Designer
Steve Walker

Supervisors/Animators
Brett Gardy, Ran Coney

Director
Steve Walker

Software Used
Alias/Wavefront PowerAnimator

Hardware Used
Silicon Graphics, Inc.

The steam path, shape, and transparency were mapped and filled in Alias, then moved frame-by-frame.

HEARTS AND DIAMONDS

Animation Studio
DESIGNefx

Client/Agency
Pennsylvania Lottery Commission

Character Creator/Designer
Darlene Hadrika

Supervisors/Animators
Blaine Cone, Norman Craft

Technical Director
Steve Walker

Director
Steve Walker

Software Used
Alias/Wavefront PowerAnimator,
Proprietary (Norman Craft)

Hardware Used
Silicon Graphics, Inc.

© Pennsylvania Lottery Commission

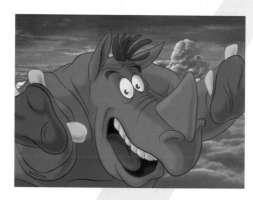

NICKELODEON
"MOVIE OPEN"

Animation Studio
(Colossal) Pictures

Client/Agency
Nickelodeon, NY

Character Creator/Designer
Dan Lee

Animators
Charlie Canfield, Dan McHale,
Tom Rubalcava

CG Animation
Zane Rutledge

Background Painters
Richard Moore, Svea Seredin,
Jill Sprado

Technical Director
John Benson

Director
Charlie Canfield

Flame Artist
Bob Roesler

Software Used
Microsoft Softimage Toonz,
Alias/Wavefront PowerAnimator,
Adobe Photoshop, Discreet
Logic's Flame Software

Hardware Used
Macintosh, Silicon Graphics, Inc.

A blue rhino galloping through a
cloudscape at sunrise soon reveals
the scene to be a movie set as he
stumbles and topples stage props.
The falling props were first animated
roughly for reference, and final cre-
ation was on SGI. All of the clouds
and texture maps were painted high
resolution in Photoshop. The ele-
ments were separated into many lev-
els, and a multi-plane camera move
was applied digitally.

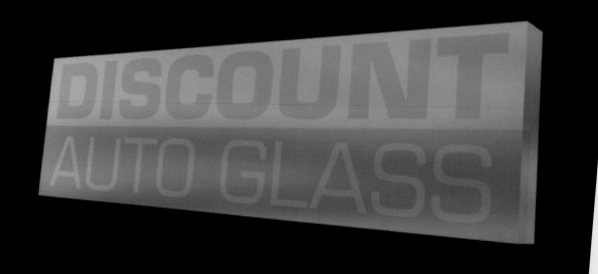

DISCOUNT AUTO GLASS
INFOMERCIAL

Animation Studio
Echo Images, Inc.

Client/Agency
Greenstone & Company

Supervisor/Animator
Andrew Heimbold

Technical Director
Andrew Heimbold

Director
Bob Greenstone

Software Used
ElectricImage Animation System,
auto•des•sys Inc. form•Z, Adobe
After Effects

Hardware Used
Macintosh

© 1996 Greenstone & Company

33

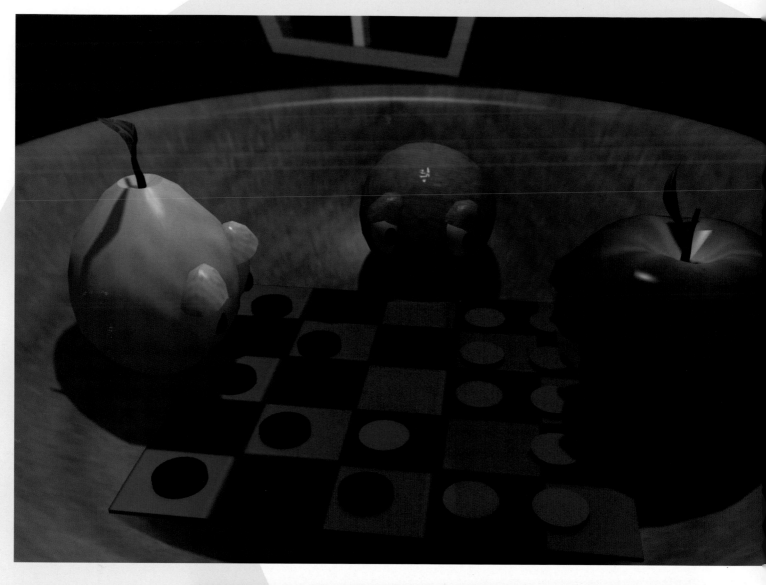

MTV FRUIT CHECKERS
COMMERCIAL

Animation Studio
Happy Boy Pat

All Design and Animation
Patrick A. Gehlen

Software Used
auto•des•sys Inc. form•Z,
ElectricImage Animation System,
Adobe Photoshop

Hardware Used
Power Macintosh

The animation was modeled in
form•Z, textured using Photoshop,
and animated and rendered using
ElectricImage.

© 1996 Patrick A. Gehlen

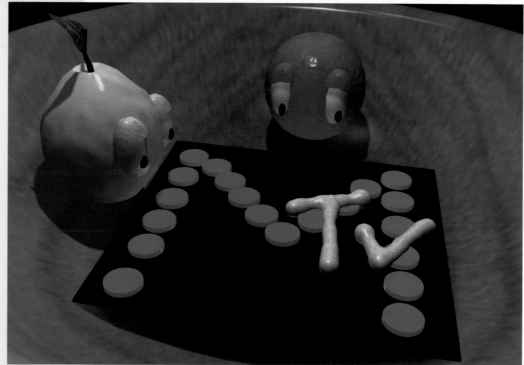

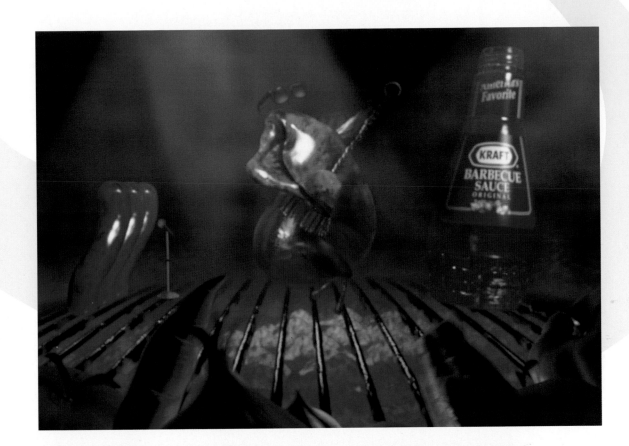

BORN TO BARBECUE

Animation Studio
Rhythm & Hues

Client/Agency
Kraft/Foote, Cone & Belding
(Chicago)

Animators
Teresa Clark, David Simmons

Technical Directors
Betsy Asher Hall, Mary Lynn
Machado, Daryl Munton, Young
Joo Paik, Juck Somsaman

Director
Henry Anderson

Lighting Director
Debbie Pashkoff

© Kraft

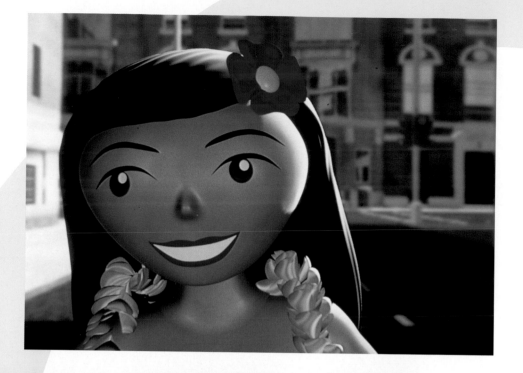

SHAKE IT

Animation Studio
Pixar

Client/Agency
Levi Strauss & Co., Foote Cone & Belding, San Francisco

Supervisors/Animators
Shawn Krause, Les Major, Doug Sheppeck, Michael Berenstein, Warren Trezevant

Technical Director
Don Schreiter

Animation/Art Director
Shawn Krause

Software used
Pixar Marionette, RenderMan® Interface

In this spot for the '96 Levi's Jeans for Women campaign, a hula girl nodder doll whose home is the back dash of a convertible comes to life when the driver leaves the car. She decides to trade in her grass skirt for a pair of "guy's fitting Levi's" and a cool pair of shades. After the switch, she kicks aside the leafy base and jumps into the front of the car, changes the radio dial and peels off into "coolsville."

LOOKING GLASS

Animation Studio
Olive Jar Studios

Client/Agency
Levi Strauss & Co., Foote Cone &
Belding, San Francisco

Character Creator/Designer
Fred MacDonald

Supervisor/Animator
Tom Gasek

Director
Tom Gasek

Senior Producer
Franny Reynolds

Executive Producer
Matthew Charde

Software Used
Quantel Henry

BUDWEISER "WORLD PARTY KICKOFF"

Animation Studio
The Post Group

Production Company
The End, Los Angeles

Client/Agency
Anheuser-Busch/Budweiser, DDB Needham

Supervisor/Animator
Steve Scott

Technical Director
Charley Randazzo

Director
Zack Snyder

Editor
Charley Randazzo

Producer
Sam Pillsbury

Software Used
Discreet Logic – Flame

Hardware Used
Silicon Graphics, Inc.– Onyx

The "Bud Blimp" was shot on a blue screen and composited by using Discreet Logic's Flame software. The challenge of the various shots was creating a realistic aspect ratio.

© Anheuser-Busch, Inc.

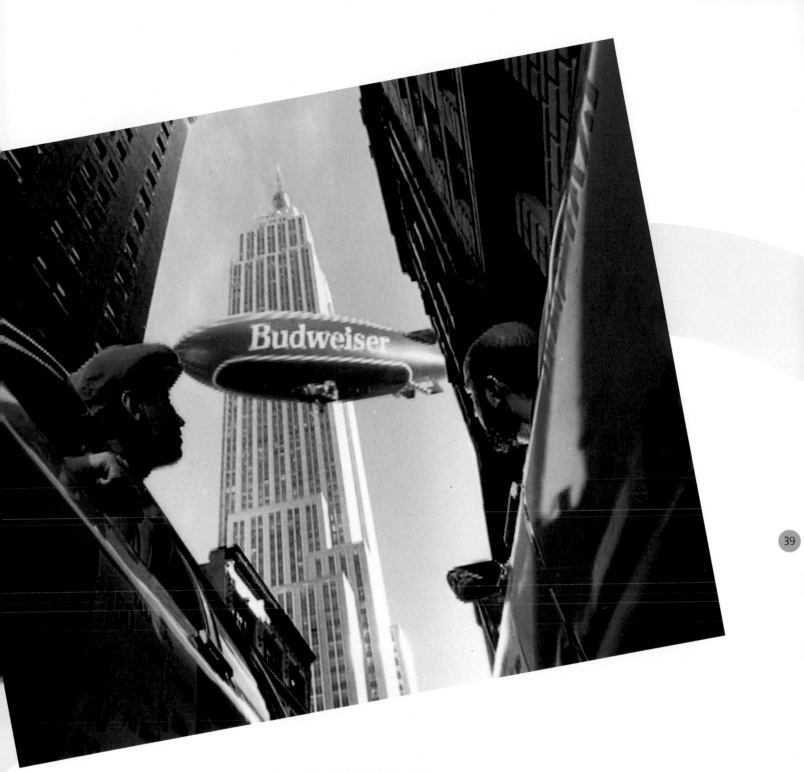

TCM "HOPPER"

Animation Studio
(Colossal) Pictures

Client/Agency
Turner Classic Movies

Traditional Animator
Tony Staachi

Morphing
Jance Allen, Colin Miller,
Jeffrey Roth

Compositing
Jance Allen, Colin Miller

3-D Animation
Jeffery Roth

Art/Tech Support
Richard Moore, Ingrid Overgard,
Jill Sprado

Technical Director
Colin Miller, Jeffery Roth

Director/Painter
Tom McClure

Software Used
Adobe After Effects and
Photoshop, Elastic Reality,
ElectricImage Animation System

Hardware Used
Macintosh, Silicon Graphics, Inc.

Traditional paintings created in
the style of Edward Hopper were
scanned into the computer.
Characters were composited and
morphed over the moving paintings,
and three-dimensional geometry and
animation were used to create
shadow passes.

40

**HALLS PENGUINS –
AIRPORT**

Animation Studio
Pacific Data Images

Production Company
Palomar Pictures

Client/Agency
Halls / J. Walter Thompson,
New York

Photo Credit
Character animation and digital
effects provided by Pacific
Data Images

© 1996 Halls

CHRISTMAS SEAL

Animation Studio
Rhythm & Hues

Client/Agency
The Coca-Cola Company, Sierra
Hotel Productions, Edge Creative

Art Director
Dan Quarnstrom

Supervisor/Animator
Nancy Kato

Effects Animation
Scott Townsend, Brian Young

Technical Director
Robert Lurye

Director
Dan Quarnstrom

Modeling
Yeen-shi Chen

Executive Producer
Bert Terreri

Software Used
Proprietary

Hardware Used
Silicon Graphics, Inc.

© "Coca-Cola," the Dynamic Ribbon Device,
and the Contour Bottle Design are registered
trademarks of The Coca-Cola Company and
are used with permission.

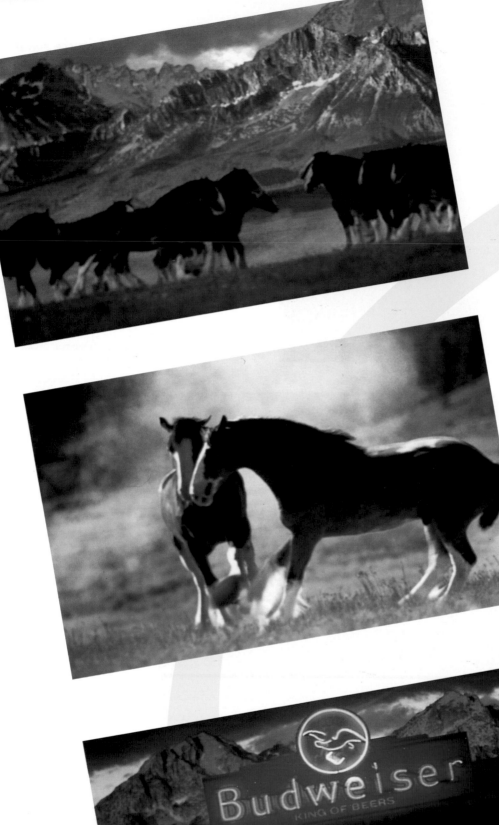

44

BUDWEISER CLYDESDALES

Animation Studio
Digital Domain

Production Company
Propaganda Films

Client/Agency
Anheuser Busch, DDB Needham,
Chicago

Visual Effects Supervisor
Fred Raimondi

Director
Anthony Hoffman

Executive Producer
Ed Ulbrich

Visual Effects Producer
John Kilkenny

Photo Courtesy of Digital Domain,
©Anheuser Busch

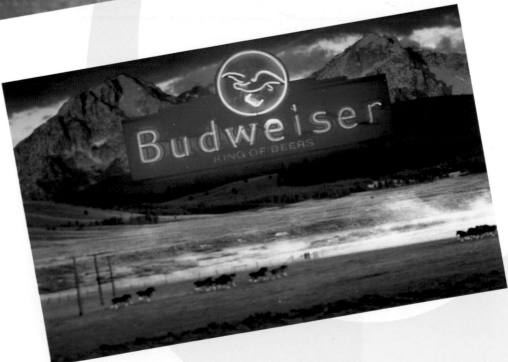

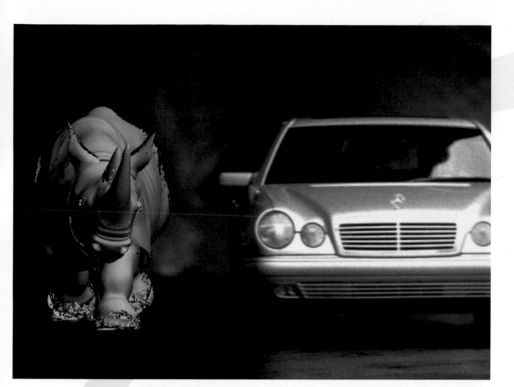

MERCEDES RHINO

Animation Studio
Digital Domain

Production Company
Bruce Dowad & Associates

Client/Agency
Mercedes Benz, Lowe & Partners

Lead Animator
Randall Rosa

Visual Effects Supervisor
Ray Giarratana

Director
Bruce Dowad

Executive Producer
Ed Ulbrich

Visual Effects Producer
Margaux Mackay

Computer Graphics Producer
Victoria Alonso

Photo Courtesy of Digital Domain,
©Mercedes Benz

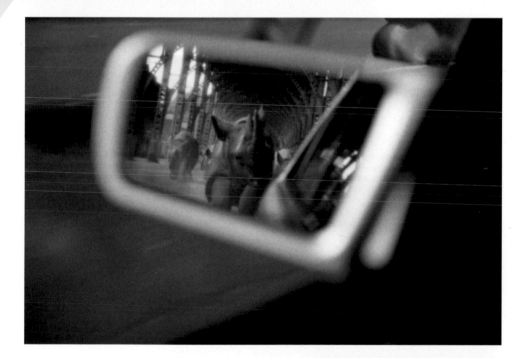

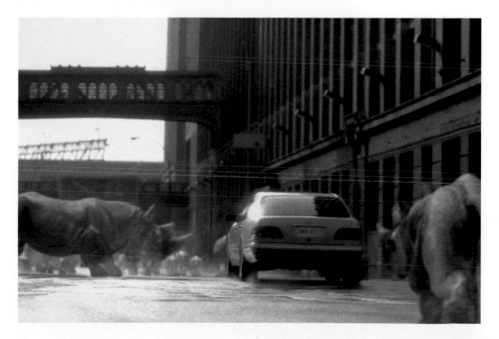

LEARNING LESSON

Animation Studio
Pixar

Client/Agency
Coca-Cola, Edge Creative

Supervisor/Animator
Jan Pinkava

Technical Director
Don Schreiter

Animation Director
Jan Pinkava

Creative Director
John Lasseter, Pixar

Producer
Susan Hamana, Pixar

Producers
Jack Harrower, Shelley Eisner,
Jonathan Schreter, Edge Creative

Creative Directors
Shelly Hochron, Len Fink,
Edge Creative

Software Used
Pixar's Marionette modeling and
animation software, RenderMan®

Pixar's Marionette modeling and
animation software was used to
create this commercial. It was
rendered using Pixar's rendering
systems, implementing the
RenderMan® Interface for 3-D
scene description, employing such
techniques as procedural shading
and texturing, self-shadowing,
motion blur, and texture mapping.

PIN BOX

Animation Studio
Pixar

Client/Agency
Coca-Cola, Edge Creative

Supervisor/Animator
Bob Peterson

Technical Director
Larry Aupperle

Animation Director
Bob Peterson

Creative Director
John Lasseter, Pixar

Producer
Susan Hamana, Pixar

Producers
Jack Harrower, Shelley Eisner,
Jonathan Schreter, Edge Creative

Creative Directors
Shelly Hochron, Len Fink,
Edge Creative

Software Used
Pixar's Marionette modeling and
animation software, RenderMan®

Pixar's Marionette modeling and
animation software was used
to create this commercial. It was
rendered using Pixar's rendering
systems, implementing the
RenderMan® Interface for 3-D
scene description, employing
such techniques as procedural
shading and texturing, self-shadowing,
motion blur, and texture mapping.

47

NISSAN
INFOMERCIAL

Animation Studio
Echo Images, Inc.

Client/Agency
Greenstone & Company

Supervisor/Animator
Andrew Heimbold

Technical Director
Andrew Heimbold

Director
Bob Greenstone

Software Used
ElectricImage Animation System,
auto•des•sys Inc. form•Z, Adobe
Photoshop

Hardware Used
Macintosh

© 1997 Greenstone & Company

NISECRET WEAPON

Animation Studio
Sk Pixar

/Client/Agency
ι, ICoca-Cola, Edge Creative

Supervisors/Animators
K Andrew Schmidt, Shawn Krause,
Wes Takahashi

Technical Director
Ba Don Schreiter

Animation Director
K Andrew Schmidt

Creative Director
K John Lasseter, Pixar

Producer
L Susan Hamana, Pixar

Producers
os Jack Harrower, Shelley Eisner,
W Jonathan Schreter, Edge Creative

Creative Directors
on Shelly Hochron, Len Fink,
pe Edge Creative

Software Used
Pixar's Marionette modeling and
animation software, RenderMan®

Pixar's Marionette modeling and
animation software was used to
create this commercial. It was
rendered using Pixar's rendering
systems, implementing the
RenderMan® Interface for 3-D
scene description, employing such
techniques as procedural shading
and texturing, self-shadowing,
motion blur, and texture mapping.

FILMS
TWO

FILMS

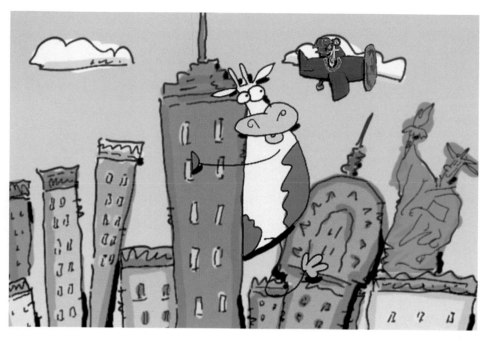

DO YOU KNOW WHERE THE COW LIVES?
SHORT FILM

Animation Studio
Serious Robots Animation

Client/Agency
Children's Television Workshop

Animator
Rose Rosely

Flint Artist
Nancy Rich

Software Used
Fractal Design Painter, Discreet Logic Flint

Hardware Used
Silicon Graphics, Inc., Macintosh

Animator Rose Rosely prepared the frames using Fractal Design Painter, converted them into separate Targa files, and sent them via ethernet to the Flint compositing system. The drawings themselves were prepared over green and Primatted over panning backgrounds using Flint software. Digital audio files were loaded into the Flint system for audio sync, then remixed and sweetened by using ProTools digital audio software.

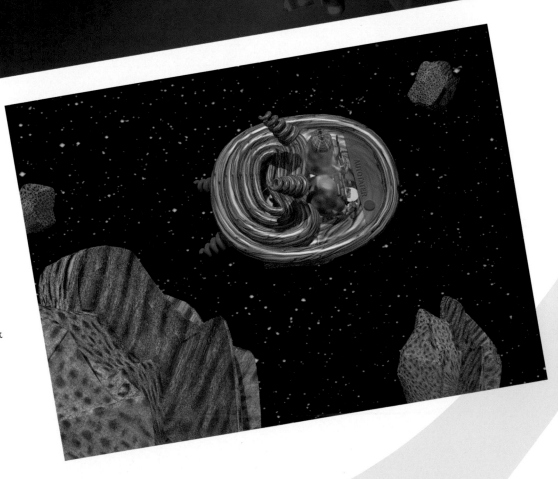

POTATOMAN VIBRATIONS
PART I
SHORT FILM

Animation Studio
Hop-To-It Graphics

**Character Creator/Designer/
Supervisor/Animator/
Technical Director/Director**
Carol J. Baker

Software Used
Fractal Design Ray Dream
Avid Videoshop

Hardware Used
Macintosh

This is an image rendere[d]
a music video featuring
"Scary Potatoes" arou[nd]
song "El Hambre Del H[...]
Del Papa Abajo."

©1996 C.J. Baker

POTATOMAN VIBRATIONS
PART II
SHORT FILM

Animation Studio
Hop-To-It Graphics

**Character Creator/Designer/
Supervisor/Animator/
Technical Director/Director**
Carol J. Baker

Software Used
Fractal Design RayDream Studio,
Avid Videoshop

Hardware Used
Macintosh

The animation was designed to fit
the lilting rhythm of the song
"Breakfast Beer Takes Effect to
Navigate the Potatoes Through
a Barrage of Meteors."

©1996 C.J. Baker

POTATOMAN VIBRATIONS
PART III
SHORT FILM

Animation Studio
Hop-To-It Graphics

Character Creator/Designer/
Supervisor/Animator/
Technical Director/Director
Carol J. Baker

Software Used
Fractal Design Ray Dream Studio,
Avid Videoshop

Hardware Used
Macintosh

The animator used the magical sounds of the electric piano as performed by one of the potatoes as an influence in the theme of this work.

©1996 C.J. Baker

57

ATOMAN VIBRATIONS
RT IV
ORT FILM

nimation Studio
op-To-It Graphics

Character Creator/Designer/
upervisor/Animator/
Technical Director/Director
Carol J. Baker

Software Used
Fractal Design Ray Dream Studio,
Avid Videoshop

Hardware Used
Macintosh

The Potatoes were hypnotized by the magical music emanating from the spaceship star song and are on a collision course with the Earth.

©1996 C.J. Baker

58

TRUCKIN'
SHORT FILM

Animation Studio
Cogswell Polytechnical College

All Design and Animation
I-Wei Huang

Software Used
Alias/Wavefront PowerAnimator

Hardware Used
Silicon Graphics Inc.

ELL'S FURY
HORT FILM

nimation Studio
hanime

l Design and Animation
ephen Chan

ftware Used
ash, Inc. Animation Master,
dobe Photoshop

ardware Used
ower Macintosh, Falcon
rthwest Pentium 90

Pencil sketches were used for the
character design and concept work.
The design was sculpted in spline
modeler, textured, and shaders were
applied. Finally, it was rendered
and composited.

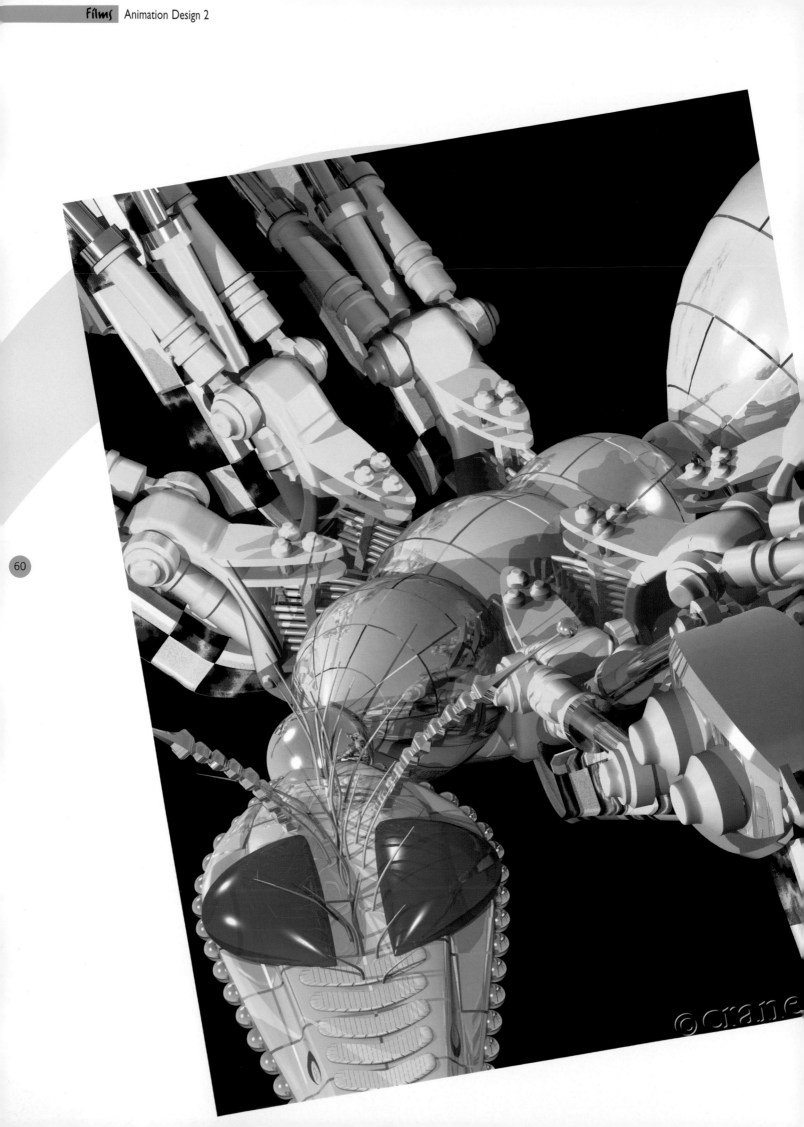

©crane

ANT ACID – THE MOVIE
SHORT FILM

Animation Studio
Sandhill Studios

Character Creator/Designer
John B. Crane

Supervisor/Animator
John B. Crane

Technical Director
John B. Crane

Director
John B. Crane

Software Used
Fractal Design Ray Dream Studio,
Adobe Photoshop

Hardware Used
Power Macintosh

The character, "Ant Acid," was created in 1996 for the '96 International Modern Masters of 3-D Contest and took first place. There are nearly 1,000 objects in the model, and each key frame required nearly 100 moves.

STEVE SAVES THE UNIVERSE, AGAIN
SHORT FILM

Animation Studio
Space Monkey Productions

Character Creator/Designer
Don Kinney

Supervisors/Animators
Don Kinney, Dreux Priore

Technical Director
Dreux Priore

Directors
Don Kinney, Dreux Priore

Other Personnel
Melissa Polakovic, Shawn Paratto,
Bill Schiffbauer, Celine Schiffbauer

Software Used
Hash, Inc. Animation Master,
Autodesk 3D Studio/Max

Hardware Used
Intel/Windows NT

Gunther was originally designed as
a foam latex puppet character.
The design is very successful as a
computer character.

© 1996 Space Monkey Productions

STEVE SAVES THE UNIVERSE, AGAIN
SHORT FILM

63

Animation Studio
Space Monkey Productions

Character Creator/Designer
Don Kinney

Supervisors/Animators
Don Kinney, Dreux Priore

Technical Director
Dreux Priore

Directors
Don Kinney, Dreux Priore

Other Personnel
Melissa Polakovic, Shawn Paratto,
Bill Schiffbauer, Celine Schiffbauer

Software Used
Hash, Inc. Animation Master,
Autodesk 3D Studio/Max

Hardware Used
Intel/Windows NT

In "Steve Saves the Universe, Again,"
there is a combination of both highly
realistic and cartoonish characters.
The environments are highly stylized
to create a totally unique look.

STEVE SAVES THE UNIVERSE
SHORT FILM

Animation Studio
Space Monkey Productions

Character Creator/Designer
Don Kinney

Supervisor/Animators
Don Kinney, Dreux Priore

Technical Director
Dreux Priore

Directors
Don Kinney, Dreux Priore

Other Personnel
Melissa Polakovic, Bill Schiffbauer,
Celine Schiffbauer, Carl Feil

Software Used
Hash, Inc. Animation Master,
NewTek Lightwave

Hardware Used
Intel/Windows NT

Steve's body was first sculpted as a
clay model and then digitized to
create the final character. The jacket
was free-form modeled to fit the body.

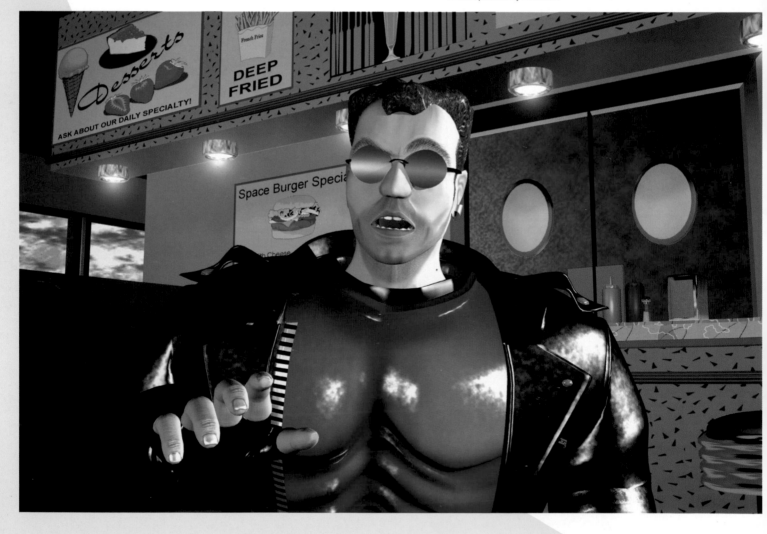

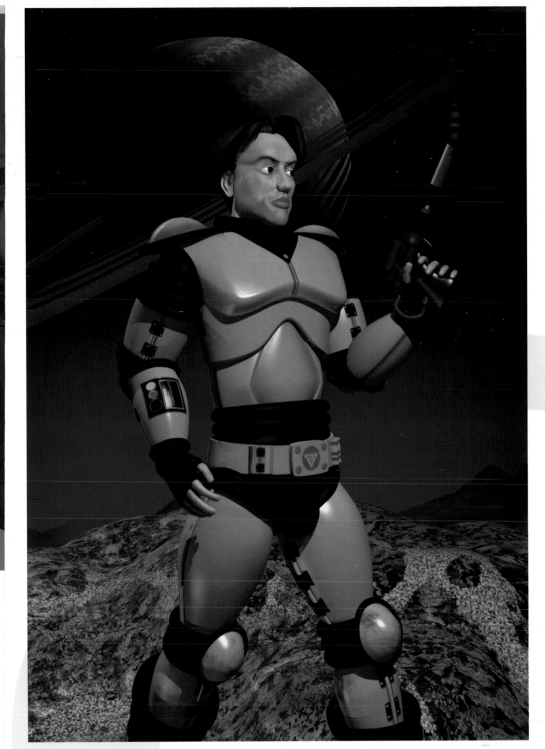

SPACE BOY
SHORT FILM

Animation Studio
Space Monkey Productions

Character Creator/Designer
Don Kinney

Supervisors/Animators
Don Kinney, Dreux Priore

Technical Director
Dreux Priore

Director
Dreux Priore

Other Personnel
Melissa Polakovic, Bill Schiffbauer

Software Used
Hash, Inc. Animation Master

Hardware Used
Intel/Windows NT

Space Boy's head was sculpted as a model and digitized; his body was modeled completely free-form from the design drawings.

© 1996 Space Monkey Productions

65

TELEVISION

GAMES

FOUR

GAMES

GEARHEADS CD-ROM

Animation Studio
R/GA Interactive

Client/Agency
Philips Media Production

Game Concept and Design
Frank Lantz, Eric Zimmerman

Character Designer
David Zung

3-D Computer Animators
Doug Johnson, Steven Blakey,
David Barosin, Edip Agi,
Fred Nilsson, Henry Kaufman

Art and Animation
Susan Brand Studios

Technical Director
Daniel Reznick

3-D Computer Graphics Director
Mark Voelpel

Art Director/Animation Director
Susan Brand

Software Used
Microsoft Softimage, R/GA
proprietary software

Hardware Used
Silicon Graphics, Inc.

The surprising and intricate play of
Gearheads emerges from the
interactions between the dozen
independent characters, giving the
game experience both fast reflex
action and subtle strategic depth.

Gearheads CD-ROM ©1996 Philips
Media, Inc., R/GA Interactive, Inc.

BURIED IN TIME

Animation Studio
Presto Studios, Inc.

Character Creator/Designer
Phil Sanders

Supervisors/Animators
Shadi Almassizadeh, Eric
Fernandes, Eric Mook

Technical Director
Shadi Almassizadeh

Director
Michel Kripalani

Texturing Department
E.J. Dixon, Frank Vitale

Software Used
ElectricImage Animation System

Hardware Used
Power Macintosh

Environments for the game were
sketched using traditional means,
then 3-D modeled, textured, and
animated on a Power Macintosh.

©1995 Presto Studios, Inc.

CREATURE CRUNCH

Animation Studio
Allied SuperProductions

Production Company
Class6 Interactive

Character Creators/Designers
Ted Mathot, John Mathot

Supervisor/Animators
Catherine Hohlfeld, Laura Blillard

Technical Directors
Ted Mathot, John Mathot

Executive Producer
Ruben Frias

Audio
Glenn Lacey, Don O'Brien

Software Used
PIXCEL

The storyline concept was develope
in-house, animated traditionally, and
then digital ink, paint, and authorin
were done on PIXCEL.

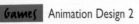

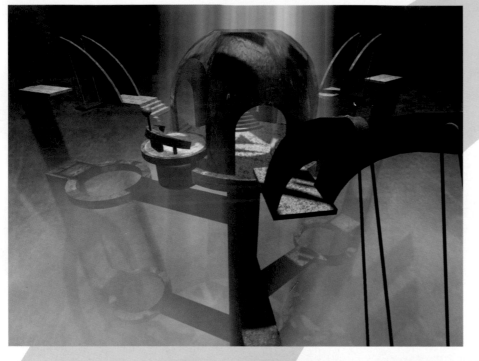

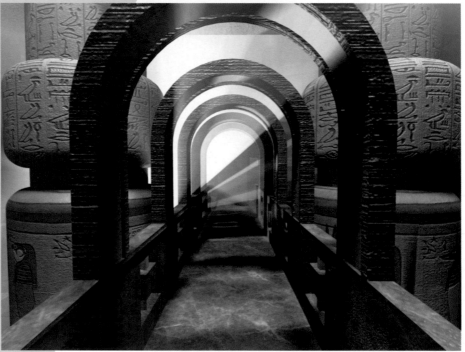

SECRETS OF THE LOST DYNASTY

Production Company
Burian Photo/Graphics

Game Developer
Smokin' Digital Corporation

Animator
Wes Burian

Software Used
ElectricImage Animation System,
auto•des•sys Inc. form•Z, Adobe
Photoshop

Hardware Used
Power Macintosh

The animator was given creative
freedom within genre-based
constraints: the work needed to
be functional and up to the visual
standard the production team had
previously outlined to him. He
created the geometry for the set,
applied texture maps, and set up
the lighting and animation paths.
Velocity curves were adjusted for
realistic motion.

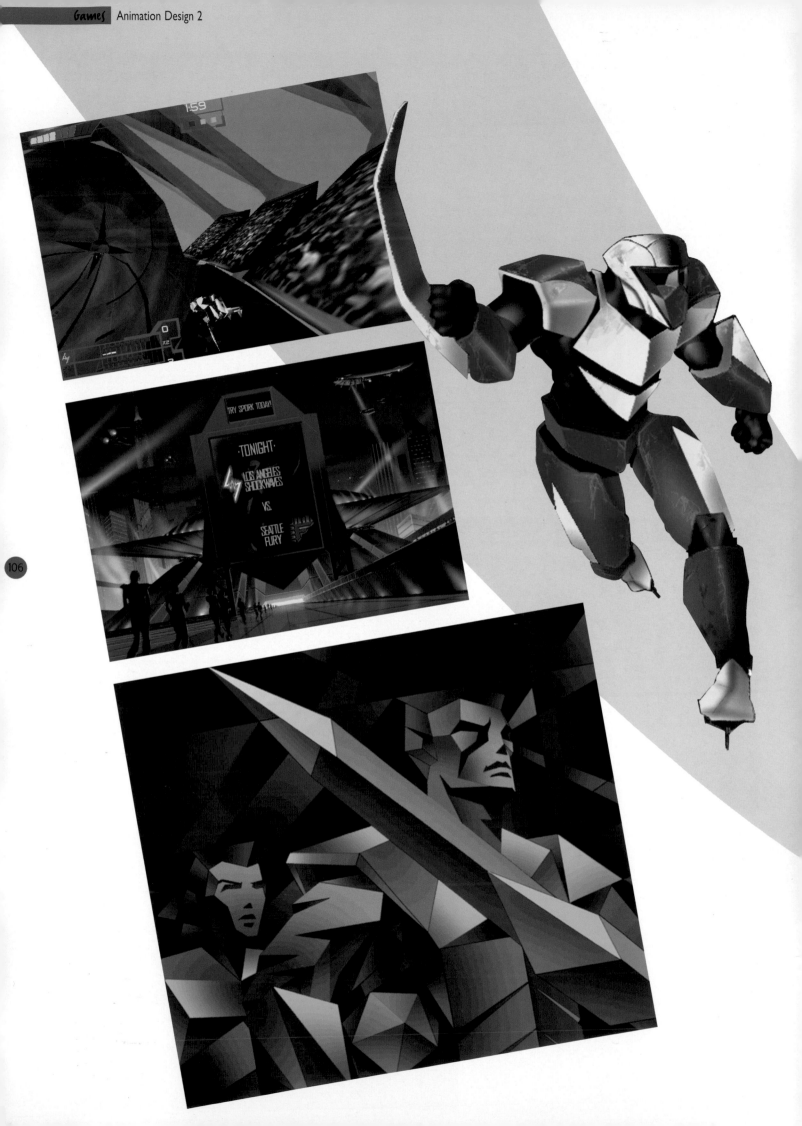

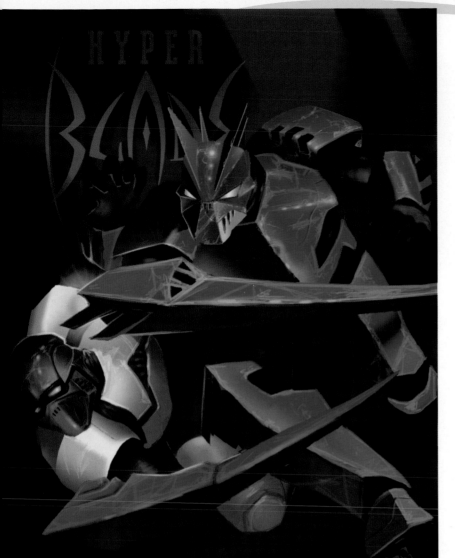

HYPERBLADE

Animation Studio
Rhythm & Hues

Production Company
Activision, Inc.

Supervisor/Animator
Lewis Peterson

Technical Director
Bill Fisher

Director/Producer
Lewis Peterson

Software Used
Proprietary system

Hardware Used
Pentium processor

Activision utilized advanced motion capture technology during a three-day video shoot at Pasadena Production Studios in Pasadena, California. To capture fast-action moves, six infrared-ray cameras were mounted in the ceiling and around the perimeter of the studio's sound stage. Over a dozen reflective balls were affixed to key points on a skater's body which produced movements on a 2-D skeleton on the computer screen.

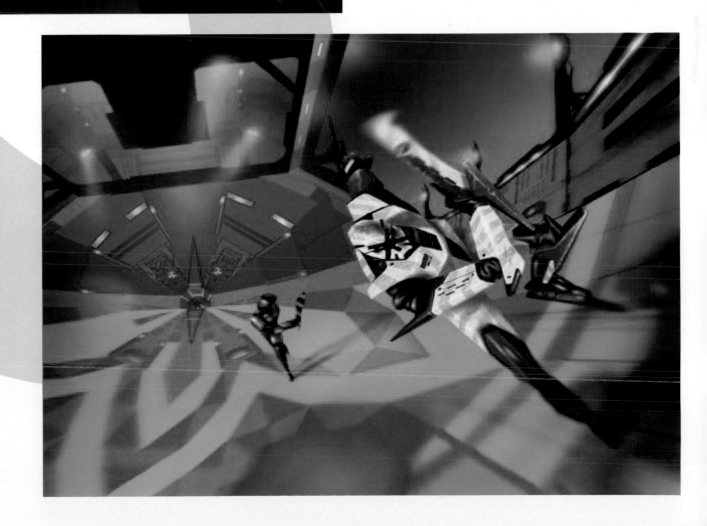

ZORK NEMESIS

Animation Studio
reZ.n8 Productions,
Mondo Media, Pyros

Developer/Publisher
Activision Inc.

Supervisor/Animator
Mauro Borrelli

Technical Directors
Mauro Borrelli, Cody Chancellor,
Greg Pyros

Director
Laird Malamed

Producer
Cecilia Barajas

Software Used
Alias/Wavefront PowerAnimator,
Autodesk 3D Studio/Max,
ElectricImage Animation System,
Adobe Photoshop

Hardware Used
Silicon Graphics, Inc.,
Macintosh, PCs

The game was modeled on
high-end machines and textured
with hand-painted art.

THE JOURNEYMAN PROJECT: PEGASUS PRIME

Animation Studio
Echo Images, Inc.,
Presto Studios, Inc.

Client/Agency
Presto Studios, Inc.

Character Creator/Designer
Jack Davis

Supervisor/Animator
Patrick Rogers

Director
Jack Davis

Designers
Phil Saunders, Tommy Yune

Modellers
Jose Albanil, Leif Einarsson,
Andrew Heimbold

Texture Maps
Tommy Yune, Jack Davis

Scene Setup/Lighting
Andrew Heimbold, Kory Jones

Software Used
ElectricImage Animation System,
auto•des•sys Inc. form•Z, Tree
Pro, Adobe Photoshop

Hardware Used
Macintosh Power PC

© 1996 Presto Studios, Inc.

109

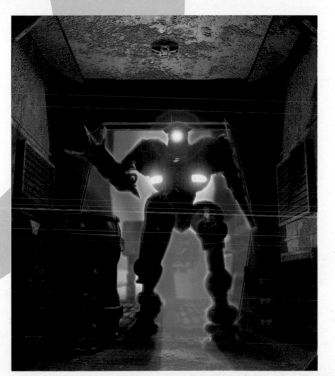

NO MAN'S EARTH

Animation Studio
Kinesoft Development

Production Company
Kinesoft Development

Character Creator/Designer
Tom Miecznikowski

Supervisor/Animator
Tom Miecznikowski

Software Used
Hash, Inc. Animation Master
and Multi-plane

Hardware Used
Intel Based P6-200

All files were created with Hash,
Inc. Animation Master, a spline-
based character animation package,
and composited using Multi-plane.

© Tom Miecznikowski – Kinesoft
Development

HEADCRASH

Animation Studio
Kinesoft Development

Production Company
Kinesoft Development

Character Creator/Designer
Tom Miecznikowski

Supervisor/Animator
Tom Miecznikowski

Software Used
Hash, Inc. Animation Master and
Multi-plane

Hardware Used
Intel Based P6-200

All files were created with Hash, Inc.
Animation Master, a spline-based
character animation package, and
composited using Multi-plane also
from Hash.

© Tom Miecznikowski –
Kinesoft Development

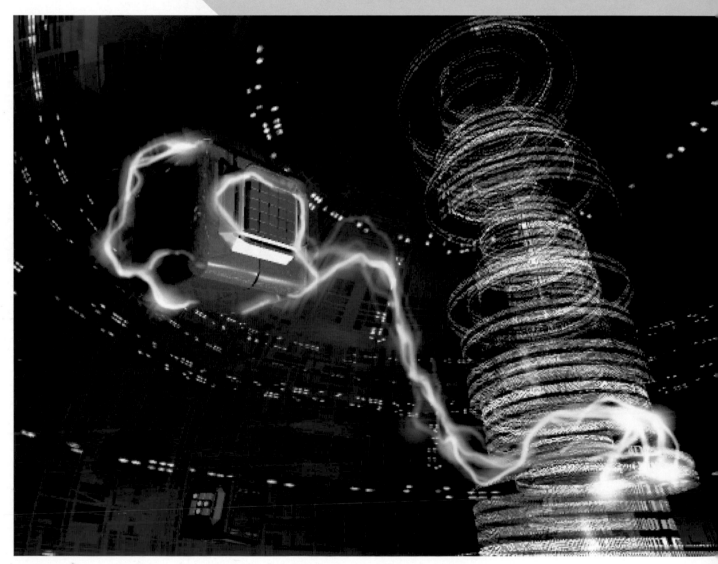

ASCENSION: MYTHS AND LEGENDS

Animation Studio
Revenant

Character Creator/Designer
Stephen C. Chan

Supervisors/Animators
Stephen C. Chan, Matt Oursbourne

Technical Director
Matt Oursbourne

Programmers
Jason Asbahr, Nathan Morse

Directors
Stephen C. Chan, Jason Asbahr

Other Personnel
Tina Leblanc

Software Used
Hash, Inc. Animation Master,
3-D Studio R4

Hardware Used
Power Macintosh,
Pentium processor

Concept sketches were used to design the characters. They were modeled in Animation Master splines and patches. Texture was applied with Meshpaint, Photoshop, and Painter. Files were then incorporated into a Realtime 3-D engine.

113

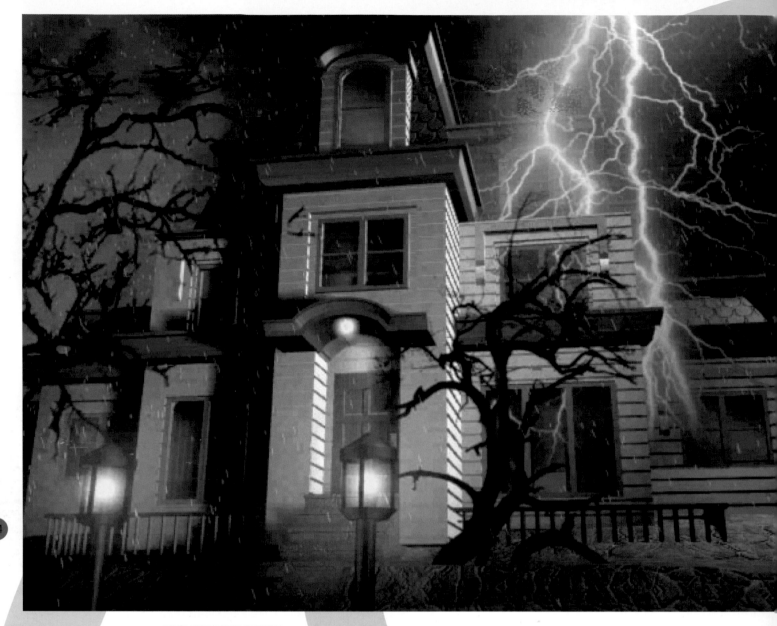

114

THE MYSTERY HOUSE

Animation Studio
Dawson 3-D, Inc.

Character Creator/Designer
Henk Dawson

Supervisor/Animators
Henk Dawson

Art Director
John Fortune (Microsoft)

Project Coordinator
Kristen Dawson

Software Used
auto•des•sys Inc. form•Z,
ElectricImage Animation System,
Adobe Photoshop

Hardware Used
Macintosh

The animator modeled the illustration
after a photograph of a weathered
house exterior. After it was modeled
and rendered, he added aging trees,
bolts of lighting, lit lamp posts, and
mysterious windows. The animation
actually takes you up the stairs in
pouring rain created with a particle
system, in the front door and into a
cozy, but dusty library.

9

Animation Studio
Tribeca Interactive

Character Creator/Designer
Mark Ryden

Supervisor/Animators
Neil Lim Sang, Joe Pasquale

Technical Directors
Brian Kromrey, Marc Blanchard

Director
Buzz Hays

Other Personnel
Todd Pound, Michele Thomas

Software Used
Microsoft Softimage, Adobe After
Effects and Photoshop, Metaflo

Hardware Used
Silicon Graphics, Inc. Indigo 2
Extremes, Power Macintosh

BAD MOJO

Animation Studio
Pulse Entertainment

Character Creators/Designers
Vinny Carrella, Phill Simon

Supervisor/Animator
Phill Simon

Technical Director
Phill Simon

Director
Vinny Carrella

Other Personnel
Dan Meblin, Dann Tarmy,
Charles Rose

Software Used
ElectricImage Animation System,
Adobe After Effects

Hardware Used
Macintosh

© Pulse Entertainment, Inc., 1996

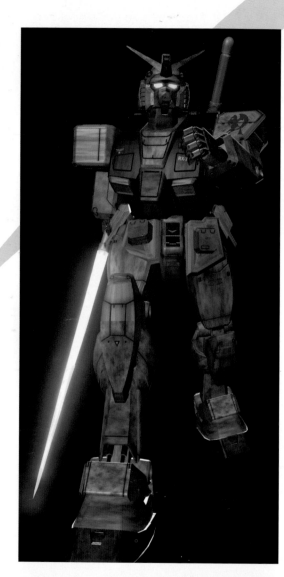

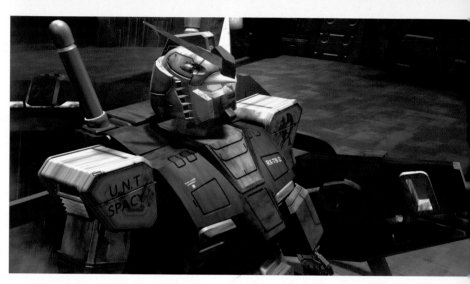

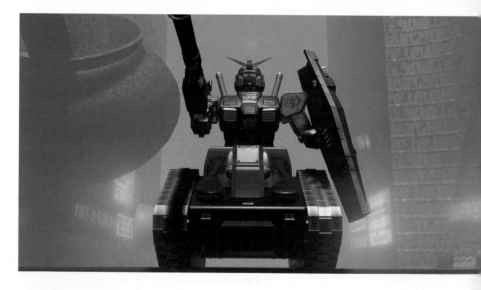

GUNDAM 0079:
THE WAR FOR EARTH

Animation Studio
Presto Studios, Inc.

Character Creator/Designer
Victor Navone

Supervisors/Animators
Shadi Almassizadeh,
Eric Fernandes

Production Manager
Farshid Almassizadeh

Texturing Department
Frank Vitale, Derek Beckor

Software Used
Alias/Wavefront PowerAnimator

Hardware Used
Silicon Graphics, Inc.

Presto Studios was asked by
Bundai/Sunrise to re-create the
Gundam characters in 3-D. And thus,
Gundam, being a very large success in
Japan as an Anime, was transformed
from traditional animation to
beautiful photorealistic animation.

© Presto Studios, Inc.
©Sunrise/Sotsu Agency

119

PEGASUS PRIME

Animation Studio
Presto Studios, Inc.

Character Creator/Designer
Tom Yun

Supervisors/Animators
Kory Jones, Shadi Almassizadeh,
Andrew Heimbold,
Michael Jackson

Technical Director
Patrick Rogers

Director
Jack Davis

Software Used
ElectricImage Animation System,
Adobe After Effects

Hardware Used
Power Macintosh

This is a remake of Presto's first title.
Environments for the game were
sketched using traditional means,
then 3-D modeled, textured, and
animated on Power Macintosh.

PAJAMA SAM IN NO NEED TO HIDE WHEN IT'S DARK OUTSIDE

MEGA MAN X3

Animation Studio
Capcom Japan

Client/Agency
Capcom Japan

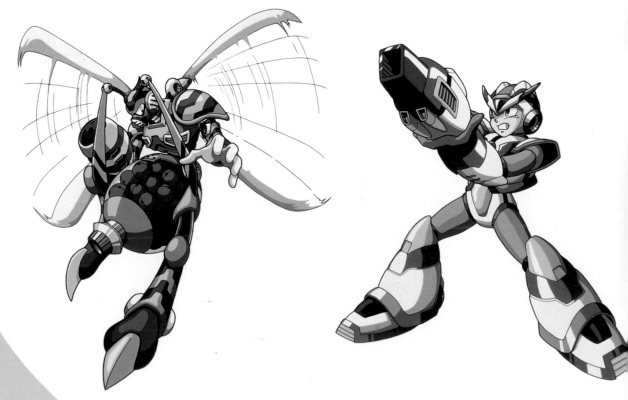

STAR GLADIATOR

Animation Studio
Capcom Japan

Client/Agency
Capcom Japan

S T U D E N

WORK

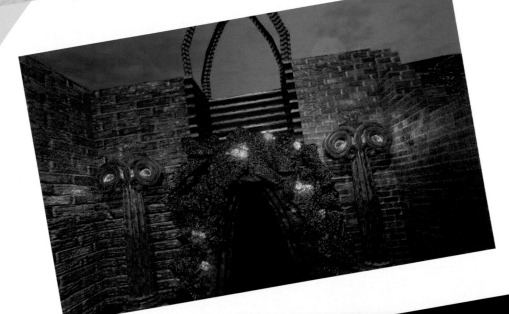

UNTITLED

Animation Studio
Cogswell Polytechnical College

Animators
Students of the School of Visual
and Performing Arts, Cogswell
Polytechnical College

Software Used
Alias/Wavefront PowerAnimator

Hardware Used
Silicon Graphics, Inc.

All images were excerpted from
short animations produced by the
students of Scott F. Hall in 1996.

THE GREEN MAN
SHORT FILM

Animation Studio
Texas A&M University
Visualization Laboratory

Character Creators/Designers
Paul Kevin Thomason, Jodi
Whitsel, Randy Hammond,
Pat Maloy

Supervisors/Animators
Paul Kevin Thomason, Jodi
Whitsel, Randy Hammond,
Pat Maloy

Technical Directors
Paul Kevin Thomason,
Jodi Whitsel, Randy Hammond

Director
Jodi Whitsel

Editor
Jeff Griswold

Music
Joe B. Vaughan, Jr.

Software Used
Wavefront's Advanced Visualizer,
Custom "splash" software –
Quintin King

Hardware Used
Silicon Graphics, Inc., Indigo Elan

The designers decided to animate
a sensitive story about fear and
acceptance that also experimented
with integrating traditional two-
dimensional animation with three-
dimensional computer animation.
The cels were drawn, colored,
scanned, converted to textures, and
applied to flat planes. Models were
created, textured, and animated with
a very deliberate attempt to design
in a style consistent with the
cel drawings.

Produced in the Texas A&M University
Visualization Laboratory Master of Science in
Visualization Sciences course VIZA 615; 3-D
Modeling and Animation II
VIZA 617: Character Animation

126

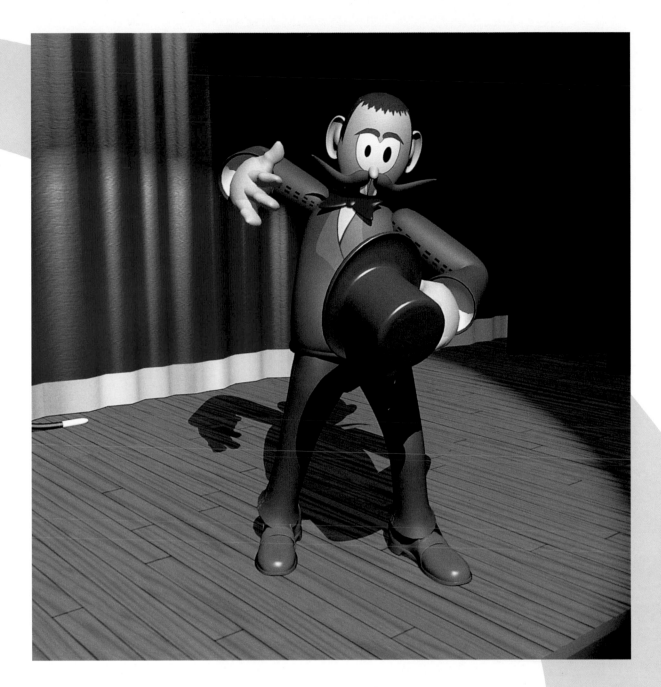

DIABLOTICA
SHORT FILM

Animation Studio
National Animation and
Design Centre

Character Creator/Designer
Dave Lajoie

Supervisor/Animator
Dave Lajoie

Technical Director
Robin Tremblay

Director
Dave Lajoie

Software Used
Microsoft Softimage

Hardware Used
Silicon Graphics, Inc., Extreme

©Centre NAD

TINY
SHORT FILM

Animation Studio
Texas A&M University
Visualization Laboratory

Character Creator/Designer
Paul Kevin Thomason

Supervisor/Animator
Paul Kevin Thomason

Technical Director
Paul Kevin Thomason

Director
Paul Kevin Thomason

Editing
Jeff Griswold, Kipp Aldrich

Software Used
Wavefront's Advanced Visualizer

Hardware Used
Silicon Graphics, Inc., Indigo Elan

The story line is simple, and the visual style is strongly influenced by the look of traditional two-dimensional cartoons. All models were created, textured, and animated in Wavefront's Advanced Visualization software. A soundtrack was created by the animator and timed to the animation. All rendered frames were dropped to video and the soundtrack was added.

Produced in the Texas A&M University Visualization Laboratory Master of Science in Visualization Sciences course VIZA 613; 3-D Modeling and Animation

O.K. OIL
S H O R T F I L M

Animation Studio
National Animation and
Design Centre

Character Creator/Designer
Deak Ferrand

Supervisor/Animator
Deak Ferrand

Technical Director
Robin Tremblay

Director
Deak Ferrand

Software Used
Microsoft Softimage

Hardware Used
Silicon Graphics, Inc., Extreme

©Centre NAD

129

KITCHEN STORY
S H O R T F I L M

Animation Studio
National Animation and
Design Centre

Character Creator/Designer
Martin Lauzon

Supervisor/Animator
Martin Lauzon

Technical Director
Robin Tremblay

Director
Martin Lauzon

Software Used
Microsoft Softimage

Hardware Used
Silicon Graphics Inc. Extreme

©Centre NAD

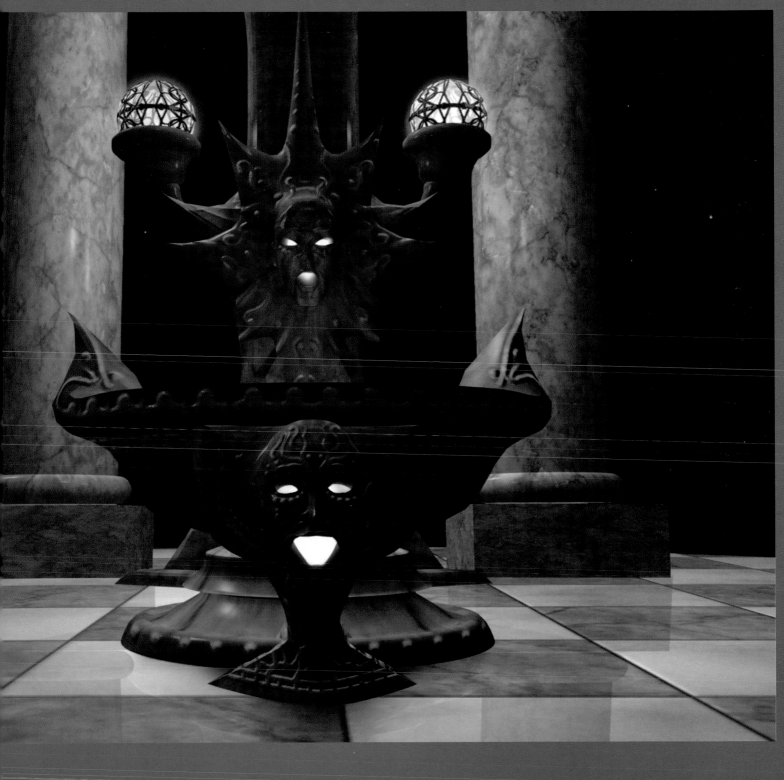

132

MECH PROTOTYPES

Animation Studio
Cogswell Polytechnical College

All Design and Animation
I-Wei Huang

Software Used
True Space 2

Hardware Used
PC

SPACE FOR RENT
SOFTWARE TUTORIAL

Software Developer
Microsoft Softimage Inc.

Character Creator/Designer
Sylvain Proteau

Supervisor/Animator
Sylvain Proteau

Directors
Bill Perkins, Judy Annette Bayne

Software Used
Microsoft Softimage Toonz

Hardware Used
Silicon Graphics, Inc. Indy

The motivation in creating "Space for Rent" was to create fun character-driven tutorials that users could work with to learn our 2-D animation software, Softimage Toonz.

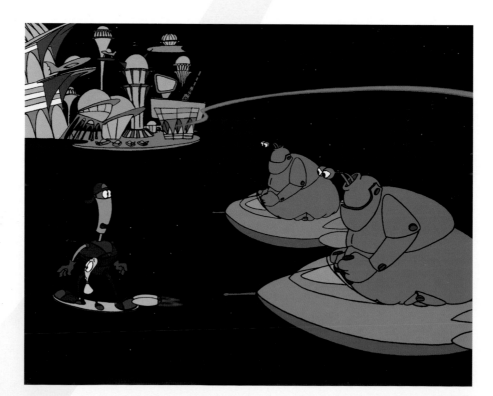

MEMORIES OF PANGEA
MUSIC VIDEO

Animation Studio
Curious Pictures

Client/Agency
East West France (Paris,
France)/K.D. Sadler (NYC, NY)

Character Creator/Designer
Eric Dyer

Head Animator
Ian Christie

Animators
Wes Grandmont, Chris Haney,
Richard Mather

**Technical Director/
Creative Director**
Steve Katz

Director
Eric Dyer

Executive Producer
Richard Winkler

Producer
Stephanie Mazarsky

Software Used
Autodesk 3D Studio/Max, Adobe
After Effects, Alias/Wavefront
PowerAnimator

Hardware Used
Intergraph Computer/Indigo
Extreme 2

Four international sites, Pyramids of
Giza, Pyramid of Palenque, Great Wall
of China, and a birch forest, were
created in 3-D Studio MAX and Alias
Power Animator. Graphic treatment
of type and projected pictograms
were created in Adobe After Effects.

Die Hard w/Vengeance
·True Lies
Mask
Mrs. Doubtfire
T-2
In The Line of Fire
Basic Instinct
Genres

Theatrical Music Multimedia Television Tour

CBO INTERACTIVE PREMIERE

Animation Studio
CBOmultimedia, div.
Cimarron/Bacon/O'Brien

Client/Agency
Cimarron/Bacon/O'Brien

Creative Director
Jill Taffet

Supervisor/Animator
John Peterson

Technical Director
John Peterson

Director
Jill Taffet

Executive Producer
Robert J. Farina

Software Used
Macromedia Director, Adobe After
Effects and Photoshop, Radius
Video Vision

Hardware Used
Power Macintosh

The CD-ROM is a full audio and
visual tour, spotlighting CBO's
impressive body of work for major
motion picture studios, music labels,
television and cable networks as well
as showing the inside of CBO's new
offices and corporate headquarters.

RECEPTION

Theatrical Music Multimedia Television Tour

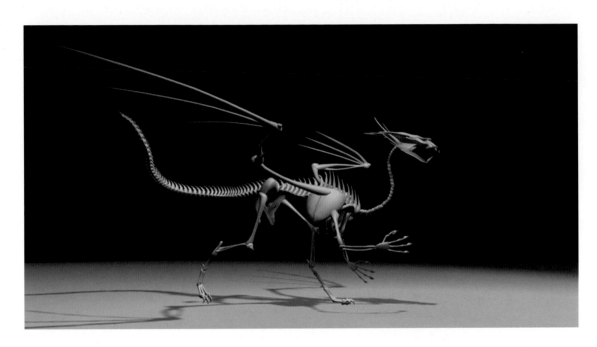

DRAGON BONES
MOTION STUDY

Animation Studio
Cogswell Polytechnical College

All Design and Animation
I-Wei Huang

Software Used
Modeled: True Space 2 Animated:
3-D Studio R4

Hardware Used
PC

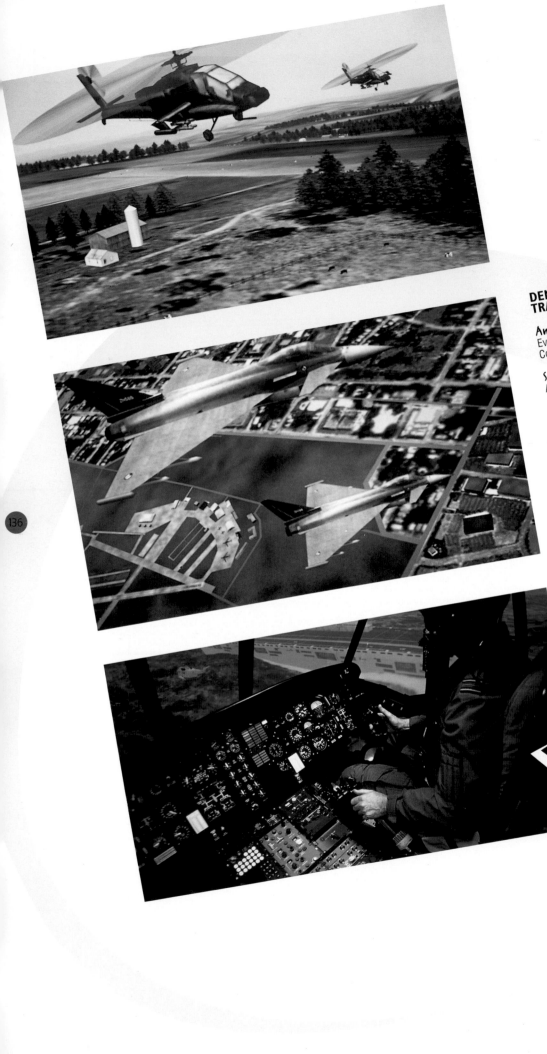

DEMONSTRATIONS FOR TRADE SHOWS

Animation Studio
Evans & Sutherland Computer Corporation

Software Used
All internal and proprietary

All images photographed from the screen or taken from data files generated in real-time by Evans & Sutherland image generators.

© Evans & Sutherland Computer Corporation

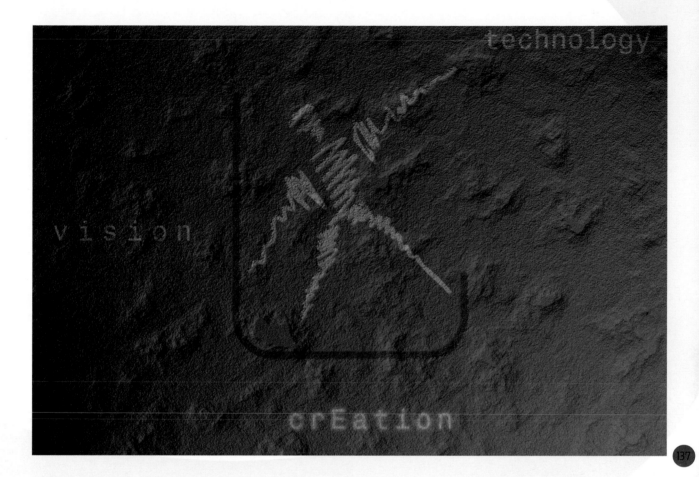

technology

vision

crEation

137

POINT OF VIEW
DEMO

Animation Studio
Point of View

Character Creator/Designer
Chris Weyers

Supervisor/Animator
Chris Weyers

Technical Director
Chris Weyers

Director
Chris Weyers

Software Used
Adobe Illustrator, Photoshop, and After Effects

Hardware Used
Power Macintosh 7500

This is a frame from a 2-D animation of a logo. The logo was patterned after petroglyphs to look like an animated character in rock. The theme for the piece is design over technology.

CIVIL RIGHTS:
THEN + NOW
CD-ROM GRAPHICS

Animation Studio
CBOmultimedia, div.
Cimarron/Bacon/O'Brien

Client/Agency
Castle Rock Entertainment,
Tammy Glover,
Producer New Media

Creative Director
Jill Taffet

Supervisors/Animators
John Peterson, Peter Wolf,
Larry Wilcox

Technical Director
John Peterson

Director
Jill Taffet

Digital Artists
Sabrian Soriano, Ryan Anista,
Elika, Larry Wilcox

Programmer
Peter Wolf

Production Manager
Amy Mattingly

Executive Producer
Robert J. Farina

Software Used
Macromedia Director, Adobe After
Effects, Premiere, and Photoshop,
Radius Video Vision

Hardware Used
Power Macintosh

This is a companion CD-ROM to
Rob Reiner's film, *Ghosts of Mississippi*.
"Civil Rights: then + now" explores
the history of the Civil Rights
movement. Whoopi Goldberg acts as
host in the hip/hop, urban, virtual
world, and the CD-ROM is both
entertaining and educational.

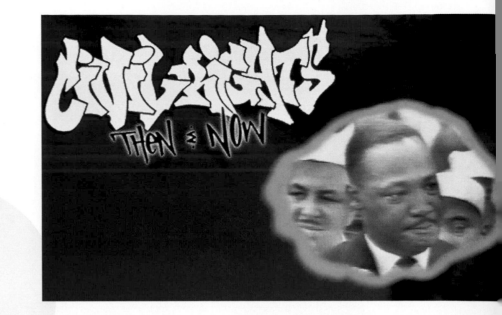

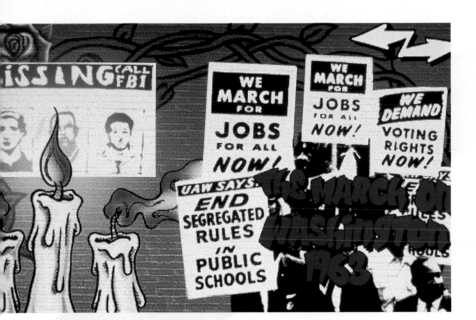

139

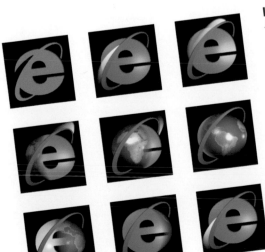

INTERNET EXPLORER
ANIMATED LOGO

Animation Studio
Dawson 3-D, Inc.

Character Creator/Designer
Henk Dawson

Supervisor/Animator
Henk Dawson

Art Director
Jeff Boettcher (Microsoft)

Project Coordinator
Kristen Dawson

Software Used
auto•des•sys Inc. form•Z,
ElectricImage Animation System,
Adobe Photoshop

Hardware Used
Macintosh

The goal of this animation was to create a simple and eye-catching icon that works well on-line. The end result was a swish with a traveling light going through the big "e." Thus, the "e" was easy to identify, and the traveling light provided viewer intrigue and staying power.

©Microsoft

SPACE JAM
INTERACTIVE KIOSK

Animation Studio
CBOmultimedia, div.
Cimarron/Bacon/O'Brien

Client/Agency
Warner Brothers, Denise Bradley,
Bob Bejan

Creative Director
Jill Taffet

Supervisor/Animator
Robert Vega

Director
Jill Taffet

Director of Production
John Peterson

Programmer
Peter Wolf

Digital Artist
Sabrina Soriano

Executive Producer
Robert J. Farina

Software Used
Radius Video Vision, MacroMedia
Director, Adobe After Effects and
Photoshop

Hardware Used
FWB Jack Hammer, FWB Array,
MicroTouch Touch Screen,
Power Macintosh

The Space Jam Interactive Kiosk was
created to promote the new Warner
Bros. movie *Space Jam* prior to its
release. The kiosk interface is a wild
and exciting scene of animated
basketballs that fly out and bounce
at you when selected. The kiosks
previews all the aspects of the movie
showing clips, pencil tests, story
and merchandise.

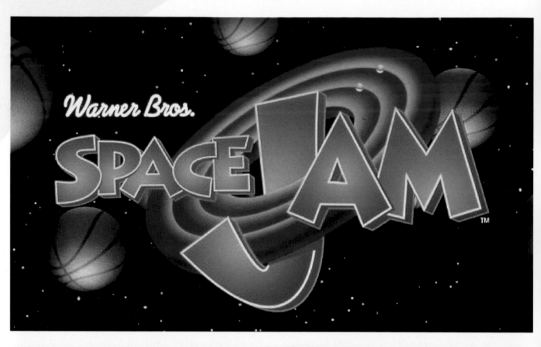

PATHWAY

Animation Studio
Mike Efford 3-D Animation

Client/Agency
Foresight Visual Communications,
Bank of Montreal

Character Creator/Designer
Mike Efford

Technical Director
Kim Couse

Director
Ted Bridgewater

Software Used
NewTek Lightwave

Hardware Used
Pentium/Windows NT

For the Bank of Montreal, this
animation emphasized the speed of
their "pathway" technology.

©Bank of Montreal, 1996

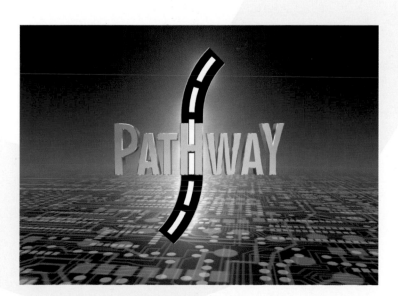

142

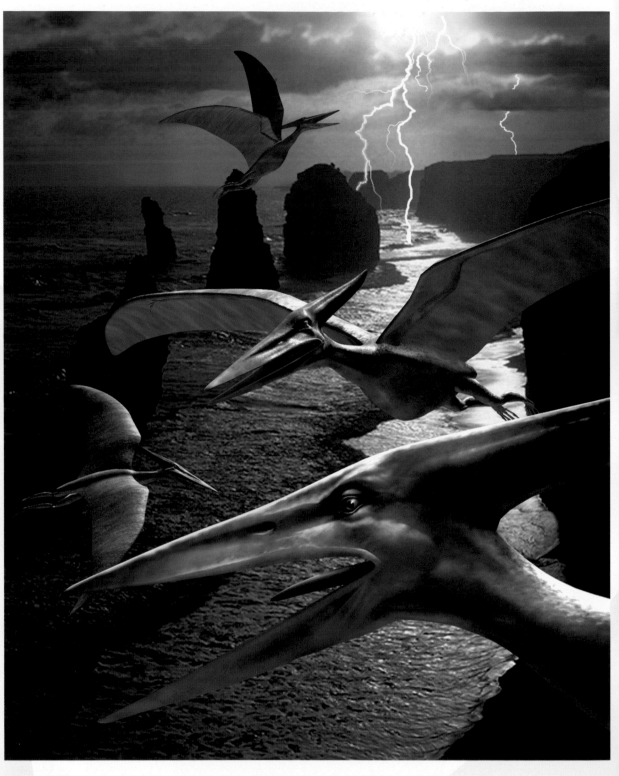

DEMO REEL

Animation Studio
Mike Efford 3-D Animation

Character Creator/Designer
Mike Efford

Editor
Scott Broad, The Post Shop

Software Used
NewTek Lightwave, Adobe
Photoshop

Hardware Used
Pentium Processor, Windows NT

Pterodactyls were modeled using
Lightwave 3.5, image processed
using Photoshop 2.5 and composited
onto a Corel Photo Background,
extensively reworked.

DEMO REEL

Animation Studio
Mike Efford 3-D Animation

Character Creator/Designer
Mike Efford

Editor
Scott Broad, The Post Shop

Software Used
NewTek Lightwave

Hardware Used
Pentium/Windows NT

This countdown sequence is from the animator's 1996 demo reel. It is a new spin on an old theme. The concept here is the contrast between the relentless march of time, and its more fleeting fragile aspects.

143

BLUE GIANT
CORPORATE VIDEO

Animation Studio
Mike Efford 3-D Animation

Client/Agency
The Post Shop

Character Creator/Designer
Mike Efford

Technical Director
Andrew Hunter

Director
Andrew Hunter

Software Used
NewTek Lightwave

Hardware Used
Pentium Processor, Windows NT

Blue Giant's logo features a robot with forklift arms. An animated character was based on it, dramatizing the power of their forklifts.

© Blue Giant, 1996

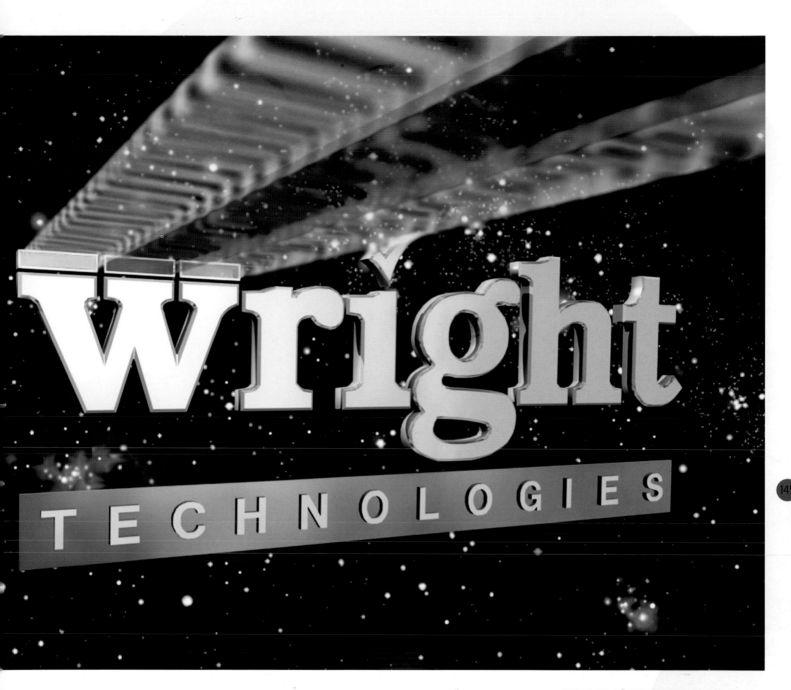

WRIGHT TECHNOLOGIES
CORPORATE VIDEO

Animation Studio
Mike Efford 3-D Animation

Character Creator/Designer
Mike Efford

Supervising Animators
Mike Efford

Editor
Scott Broad

Software Used
NewTek Lightwave

Hardware Used
Amiga 2000

For Wright Technologies, a pre-press
software developer based in Australia,
the animator extended the yellow,
magenta and cyan colors of their
logo into pulsing laser-like beams.

© Mike Efford, 1995

+4 GROOVE

HELIX-HELIX PACKING
SCIENTIFIC
VISUALIZATION

Animation Studio
Pittsburgh Supercomputing Center

Supervisor/Animator
Gregory Foss

Software Support
Grace Giras, Pittsburgh
Supercomputing Center

Researcher
David Deerfield, Pittsburgh
Supercomputing Center

Software Used
Microsoft Softimage Creative
Environment, GRAPHX

Hardware Used
Silicon Graphics, Inc. Indigo 2
Extreme, Silicon Graphics, Inc.
Crimson Reality Engine

Researchers' GRAPHX models
were imported into Softimage for
materials, lighting, choreography,
and rendering.

PUMP UP THE VOLUME
SCIENTIFIC
VISUALIZATION

Animation Studio
Pittsburgh Supercomputing Center

Supervisor/Animator
Gregory Foss

Software Support
Grace Giras

Researchers
David McQueen, Charles Peskin,
NYU

Software Used
Microsoft Softimage

Hardware Used
Silicon Graphics, Inc. Extreme,
and Crimson Reality Engine

The researchers' data was imported
into Softimage as splines. The splines
were used to build texture mapped
tubes.

147

TORNADO WATCH
SCIENTIFIC
VISUALIZATION

Animation Studio
Pittsburgh Supercomputing Center

Supervisor/Animator
Gregory Foss

Software Support
Grace Giras, Pittsburgh
Supercomputing Center

Researchers
Kevin Droegemeier, Ming Xue,
C.A.P.S., University of Oklahoma

Software Used
Microsoft Softimage Creative
Environment, AVS

Hardware Used
Silicon Graphics, Inc. Indigo 2
Extreme, Silicon Graphics, Inc.
Crimson Reality Engine

The researchers' data was visualized
in A.V.S. and output as isosurface
geometries. Geometry was imported
into Softimage for materials, lighting,
choreography, and rendering.

THE EINSTEIN VIRTUAL WORLD

Animation Studio
Dawson 3-D, Inc.

Character Creator/Designer
Henk Dawson

Supervisor/Animators
Henk Dawson

Art Director
Maz Kessler (Microsoft)

Software Used
auto•des•sys Inc. form•Z,
ElectricImage Animation System,
Adobe Photoshop

Hardware Used
Macintosh

The animator researched and
sketched three scenes: the
observatory, modeled on the one at
University of Washington; a home
office, modeled on Einstein's; and a
patent office, modeled on the one in
which Einstein worked. Many hours
were spent picking out textures and
setting the lights. All the scenes were
rendered and animated in
ElectricImage.

ELECTRIC IMAGE
DEMO REEL

Animation Studio
Happy Boy Pat Studios

All Design and Animation
Patrick A. Gehlen

Software Used
ElectricImage Animation System,
Adobe Photoshop, Hash, Inc.
Animation Master, Media Paint,
auto•des•sys Inc. form•Z

Hardware Used
Power Macintosh

The fountain was sculpted in
MH3-D, and then brought into the
twilight realm of Cyber Angel and his
temple on the hill. The textures were
done in Photoshop.

© 1996 Patrick A. Gehlen

ORBIT
SOFTWARE DEMO

Software Developer
Microsoft Softimage Inc.

Character Creator/Designer
Gunnar Hansen

Animation/Modeling
Tim Stevenson, Raonull Conover,
Vincent Lu, Marc Villeneuve

**Whitefish Bridge Interior Design
and Modeling**
Sammy Nelson

**Eddie Morph and
Visual Displays**
Sophie Vincelette

Software Used
Microsoft Softimage, 3-D
and Eddie, Particle

Hardware Used
Silicon Graphics, Inc.

No models were pre-made and none
of the animation was captured. The
volumetric shader and the lens flare
shader on Mental Ray were used for
rendering. Meta-Clay was used for the
3-D morph and then cross-dissolved
into patch objects with Eddie. Eddie
was also used for textures, credits,
2-D morph, compositing, and image
filters.

SWEET TOOTH
SOFTWARE DEMO

Software Developer
Microsoft Softimage Inc.

Supervisor/Animator
Brad Hiebert

Software Used
Microsoft Softimage, Autodesk 3D
Studio/Max

Hardware Used
NT Platform

Sweet Tooth was modeled, animated,
and rendered using Softimage 3-D on
the NT Platform. The playful 30
second animation went from napkin
to final in 3 long weeks, with one
animator in the chair.

154

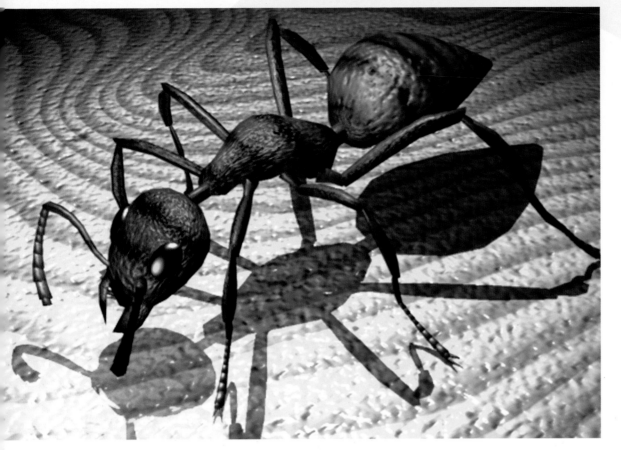

THE ANT
MOTION STUDY

All Design and Animation
I-Wei Huang

Software Used
Modeled: True Space 2 Animated:
3-D Studio R4

Hardware Used
PC

155

THE TRANSPORTER SHIP
SOFTWARE DEMO

Animation Studio
Dawson 3-D, Inc.

Character Creator/Designer
Henk Dawson

Supervisor/Animators
Henk Dawson

Art Director
Michelle Lynch (Evans Group)

Software Used
auto•des•sys Inc. form•Z,
ElectricImage Animation System,
Adobe Photoshop

Hardware Used
Macintosh

This animation was inspired by combining two very different objects: a cliché sci-fi ship and an angel fish. He sketched the top, side, and front view to get a quick overview of all angles needed to create a realistic model. After modeling the ship, he spent a lot of time trying to add earthly elements (i.e., stains, scratches, hieroglyphs) to an unearthly scene.

©Henk Dawson

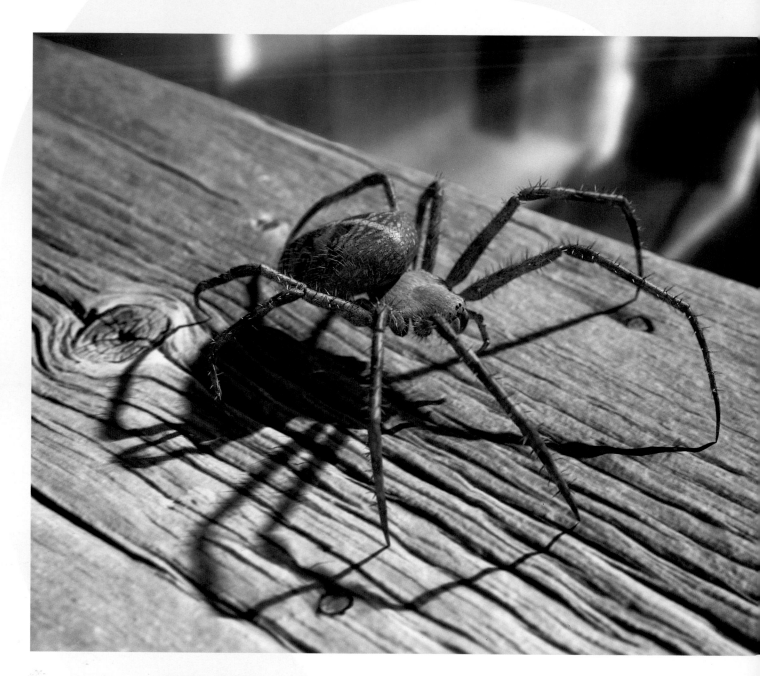

MULTIPED SPIDER
SOFTWARE DEMO

Software Developer
Microsoft Softimage Inc.

Character Creator/Designer
Gunnar Hansen

Animator
Gunnar Hansen

Effects Programmer
Jason Bright

Software Used
Microsoft Softimage

Hardware Used
Silicon Graphics, Inc. Extreme

All elements were created using
Softimage/3D. The spider was
animated using a behavioral effect
called Multiped which allowed realistic
spider motion to be animated in a
matter of hours. The images were
rendered with Mental Ray.

BODY, MIND, SOUL
SOFTWARE DEMO

Animation Studio
IDEO San Francisco

Animators
Dennis Poon, Peter Spreenberg,
Neil Wilson

Director
Peter Spreenberg

Software Used
Marcomedia Extreme 3-D

Hardware Used
Intel Pentium Pro

This short animation was created by
IDEO for the launch of Macromedia's
new software, Extreme 3-D. The
purpose was to create an exciting
piece that would demonstrate the
potential visualization and animation
capabilities of this accessible and
affordable application.

©1995 Macromedia

157

ALLIED SUPERPRODUCTIONS
Class6 Entertainment/Interactive
6777 Hollywood Boulevard
7th Floor
Hollywood, CA 90028

CAROL J. BAKER
16610 NE 180th Place
Woodinville, WA 98072

TRAVIS M. BANKS
1856 Cherry Hill Drive
Discovery Bay, CA 94514

BLUE SKY STUDIOS
344 Tennyson Avenue
Palo Alto, CA 94301

BURIAN PHOTO/GRAPHICS
3961 Bow Road
Victoria, BC V8N 3B2
Canada

CBO MULTIMEDIA
758 N Highland Avenue
Hollywood, CA 90038

CINESITE
1017 N Las Palmas Avenue, #300
Hollywood, CA 90038

COGSWELL POLYTECHNIC
1175 Bordeau Drive
Sunnyvale, CA 94089

(COLOSSAL) PICTURES
2800 Third Street
San Francisco, CA 94107

CURIOUS PICTURES
Minneapolis, MN 55408

DAWSON 3-D, INC.
3519 170th Place NE
Bellevue, WA 98001

DESIGNEFX
506 Plasters Avenue
Atlanta, GA 30324

DIGITAL DOMAIN
300 Rose Avenue
Venice, CA 90291

ECHO IMAGES
4747 Morena Blvd.
Suite 100
San Diego, CA 92121

EVANS & SUTHERLAND COMPUTER CORP.
600 Komas Drive
Salt Lake City, UT 84108

HAPPY BOY PAT STUDIOS
1955 Crestshire Dr.
Glendale, CA 91208

FORK
(a division of IDEO San Francisco)
Pier 28 Annex
San Francisco, CA 94105

INDUSTRIAL LIGHT & MAGIC
P.O. Box 2459
San Rafael, CA 94912

KINESOFT
1090 Johnson Drive
Buffalo Grove, IL 60089

MICROSOFT
One Microsoft Way
Redmond, WA 98052

MIKE EFFORD 3-D ANIMATION
69 Skylark Rd.
Toronto, ON M6S 4M5
Canada

MODERN CARTOON
228 Main Street
Suite 12
Venice, CA 90291

NATIONAL ANIMATION & DESIGN CENTRE
3510, boul. Saint Laurent.Bureau 202
Montreal, QB H2X 2V2
Canada

OLIVE JAR
35 Soldiers Field Place
Boston, MA 02135

PACIFIC DATA IMAGES
3101 Park Boulevard
Palo Alto, CA 94306

PITTSBURGH SUPERCOMPUTING CENTER
4400 Fifth Avenue
Pittsburgh, PA15213

PIXAR ANIMATION STUDIOS
1001 W. Cutting Blvd.
Suite 200
Richmond, CA 94804

POINT OF VIEW (CHRIS WEYERS)
24899 Devaney Rd.
Arcadia, IN 46030

PRESTO STUDIOS
5414 Overland Drive
Suite 200
San Diego, CA 92121

PULSE ENTERTAINMENT
246 First Street, #402
San Francisco, CA 94105

R/GREENBURG & ASSOCIATES
350 W 39th Street
New York, NY 10018

RHYTHM & HUES
5404 Jandy Place
Los Angeles, CA 90066

RONIN ANIMATION
420 N 5th Street
Suite 708
Minneapolis, MN 55401-1372

SANDHILL STUDIOS
P.O. Box 9413
Santa Fe, NM 87501

SERIOUS ROBOTS
1610 Midtown Place
Raleigh, NC 27609

SPACE MONKEY PRODUCTIONS
400 S Highland Avenue, #5
Pittsburgh, PA 15206

STUART SHARPE
42 Sunset Way
San Rafael, CA 94901

THE POST GROUP
6335 Homewood Avenue
Los Angeles, CA 90028

TWO HEADED MONSTER
6161 Santa Monica Boulevard Suite 100
Hollywood, CA 90038

ALLIED SUPERPRODUCTIONS
100–101, 102-103

BANKS, TRAVIS M.
70, 77

BLUE SKY STUDIOS, INC.
23, 24, 25, 26, 51

BURIAN PHOTO/GRAPHICS
96–97, 104–105

CAPCOM JAPAN
120, 121

**CBOMULTIMEDIA, DIV.
CIMARRON/BACON/O'BRIEN**
134, 138, 140

CHANIME
59

**COGSWELL POLYTECHNICAL
COLLEGE**
58, 124–125, 132, 135

(COLOSSAL) PICTURES
32, 39

CURIOUS PICTURES
8–9, 10, 16, 17, 18, 133

DAWSON 3-D, INC.
114, 139, 148–149, 155

DESIGNEFX
29, 30, 31, 80–81, 89, 92, 93

DIGITAL DOMAIN
42, 43, 44, 45

ECHO IMAGES, INC.
32–33, 48, 109

**EVANS & SUTHERLAND COMPUTER
CORPORATIONS**
136

HAPPY BOY PAT STUDIOS
34, 150–151

HOP-TO-IT GRAPHICS
56, 57

HUANG, I-WEI
155

IDEO SAN FRANCISCO
157

**INDUSTRIAL LIGHT & MAGIC
PRODUCTION**
50

**IOWA STATE UNIVERSITY
VISUALIZATION LABORATORY**
68–69

KINESOFT DEVELOPMENT
110–111, 112

LUDMILA SLUSSARENKO
72, 78

MICROSOFT
1, 2–3, 4–5, 71, 132, 152–153, 154, 156

MIKE EFFORD 3-D ANIMATION
141, 142, 143, 144, 145

MODERN CARTOONS, LTD.
85, 86, 87

**NATIONAL ANIMATION AND
DESIGN CENTRE**
127, 129

NICHOLAS FRANK CO.
90, 91, 94, 95

OLIVE JAR STUDIOS
19, 20, 21, 22, 37

PACIFIC DATA IMAGES
40, 82–83, 84

**PITTSBURGH SUPERCOMPUTING
CENTER**
146, 147

PIXAR
12, 36, 46, 47, 49

POINT OF VIEW
66–67, 137

PRESTO STUDIOS, INC.
99, 118, 119

PULSE ENTERTAINMENT
116–117

R/GA INTERACTIVE
98

R/GREENBERG ASSOCIATES
11, 14, 15

REVENANT
113

**REZ.N8 PRODUCTIONS,
MONDO MEDIA, PYROS**
108

RHYTHM & HUES
7, 35, 41, 106–107

RONIN ANIMATION
73, 74–75

SANDHILL STUDIOS
60–61

SERIOUS ROBOTS ANIMATION
13, 54–55

SPACE MONKEY PRODUCTIONS
62, 63, 64, 65

STUART SHARPE
67

**TEXAS A&M UNIVERSITY
VISUALIZATION LABORATORY**
122–123, 126, 128

THE POST GROUP
38

TRIBECA INTERACTIVE
115

TWO HEADED MONSTER
27, 28, 88, 90

**UNIVERSITY OF WASHINGTON,
ANIMATION ARTS PROGRAM**
52–53, 79

WARNER BROS. FEATURE ANIMATION
76–77

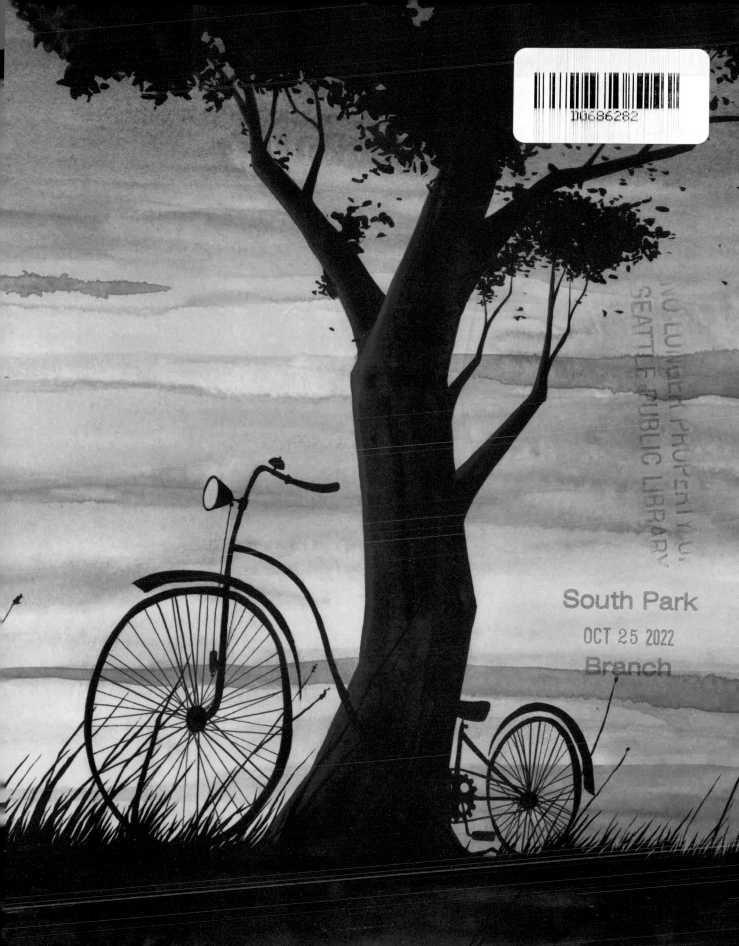

Para Marc, Adriel y Yuna.
— Susanna Isern

A Yago, le mando mi correspondencia allá donde se halle.
— Daniel Montero Galán

Cartas en el bosque
© 2016 del texto: Susanna Isern
© 2016 de las ilustraciones: Daniel Montero Galán
© 2016 Cuento de Luz SL
Calle Claveles, 10 | Urb. Monteclaro | Pozuelo de Alarcón | 28223 | Madrid | Spain
www.cuentodeluz.com
1ª edición
ISBN: 978-84-16733-98-9
Impreso en PRC por Shanghai Cheng Printing Company, marzo 2020, tirada número 1804-9
Reservados todos los derechos

Este libro está impreso sobre **Papel de Piedra**© con el certificado de **Cradle to Cradle**™ (plata). Cradle to Cradle™, que en español significa «de la cuna a la cuna», es una de las certificaciones ecológicas más rigurosa que existen y premia a aquellos productos que han sido concebidos y diseñados de forma ecológicamente inteligente.

Cuento de Luz™ se convirtió en 2015 en una **Empresa B Certificada**©. La prestigiosa certificación se otorga a empresas que utilizan el poder de los negocios para resolver problemas sociales y ambientales y cumplir con estándares más altos de desempeño social y ambiental, transparencia y responsabilidad.

Cartas
en el
bosque

Susanna Isern

Daniel Montero Galán

Todas las mañanas, muy temprano, el viejo cartero
sale de casa con el zurrón lleno. Sube a la bicicleta y
empieza su camino.

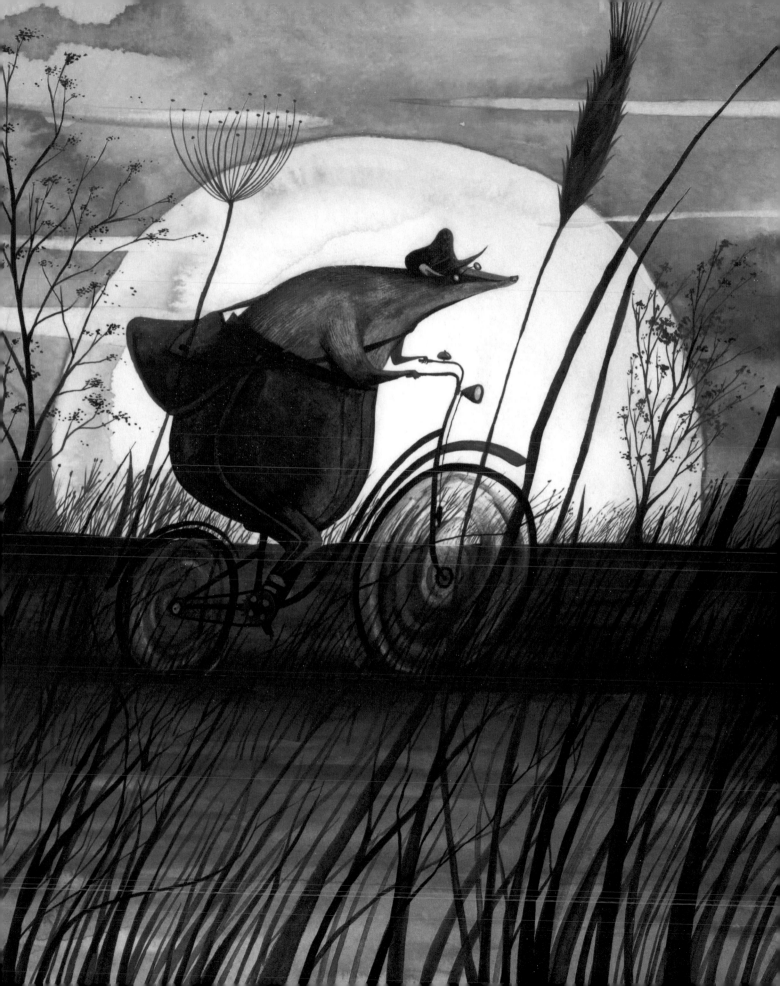

El cartero va de puerta en puerta,
toca el timbre y solo dice tres palabras.

—Ardilla, carta va.

Las susurra tan bajito que ni siquiera
él puede oírlas.

—Erizo, carta va.

```
Querida Ardilla,

Disculpa el pinchazo que ayer
te di en el mercado sin querer.
Para compensarte te invito a cenar.
Te espero a las ocho. Ruego puntualidad.

          —Erizo
```

Estimado Erizo,

Ayer me pinchó usted.

Pero no se preocupe, sé que fue sin querer.

Si me invita a cenar, podríamos charlar.

Voy a venir a las ocho, no se hable más.

—Ardilla

A veces los vecinos del bosque le ofrecen un café. Pero el cartero dice que no con gesto tímido y, rápidamente, desaparece tras el polvo de su bicicleta.

—Lirón, carta va.

Disculpa Lirón,

Hasta el día de ayer no me di cuenta

de que estoy picando junto a tu madriguera.

Con lo que te gusta el reposo

mejor me busco otro tronco.

—Pájaro Carpintero

Nunca se baja de ella.

—**Carpintero, carta va.**

Apreciado Pájaro Carpintero,

El árbol donde empezaste a picar
está junto a mi matorral.
Ahora no puedo dormir apenas.
¿Podrías trasladarte a otra arboleda?

—Lirón

Los animales lo ven todos los días recorrer el bosque mientras pedalea. Pero prácticamente no saben nada de él.

—**Mariposas, carta va.**

En realidad el cartero es un auténtico desconocido.

—**Tortuga, carta va.**

Bonitas Mariposas,

Hay sitio de sobra en mi caparazón
para que toméis tranquilamente el sol.
Y si empezara a llover...
podríais pasar dentro a tomar un té.

—Tortuga

Sabia Tortuga,

Nos encantaría visitarte,

rodearte de alas y darte aire.

Posarnos y adornar tu caparazón.

Escuchar tus historias mientras tomamos el sol.

—Mariposas

Algunos aseguran que por alguna razón el cartero está triste y que por eso es tan callado.

—**Oso, carta va.**

Pero quién sabe, nunca nadie le preguntó.

—**Conejo, carta va.**

Amigo Oso,

Cuando te veo por el lago nadar
contigo me gustaría estar.
Pero además de ser algo miedoso,
con estas patas cortas, no floto.

—Conejo

Querido Conejo,

Una buena solución encontré
para cuando me bañe otra vez.
Podrías montar sobre mi espalda
como si de un gran bote se tratara.

—Oso

Y así, durante todo el día, el viejo cartero reparte cartas por el bosque. Visita al lobo, al ciervo, a las ranas, a la marmota, al zorro, a la mofeta, a los peces del río...

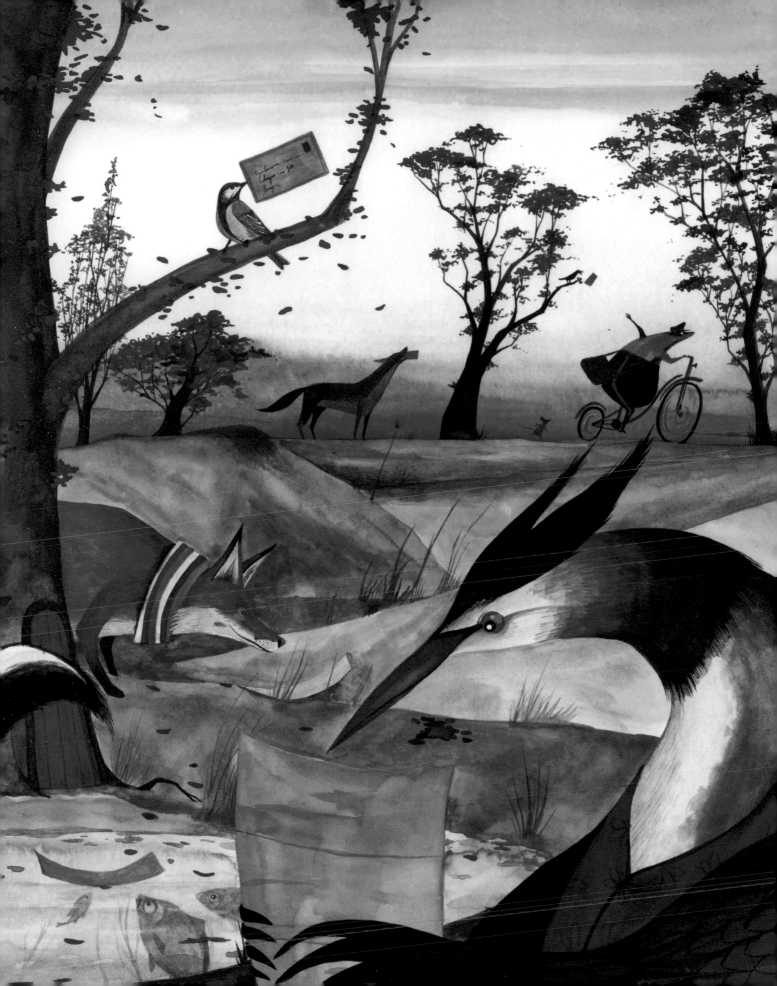

Al anochecer, con el zurrón
vacío y muy cansado,
regresa a casa.

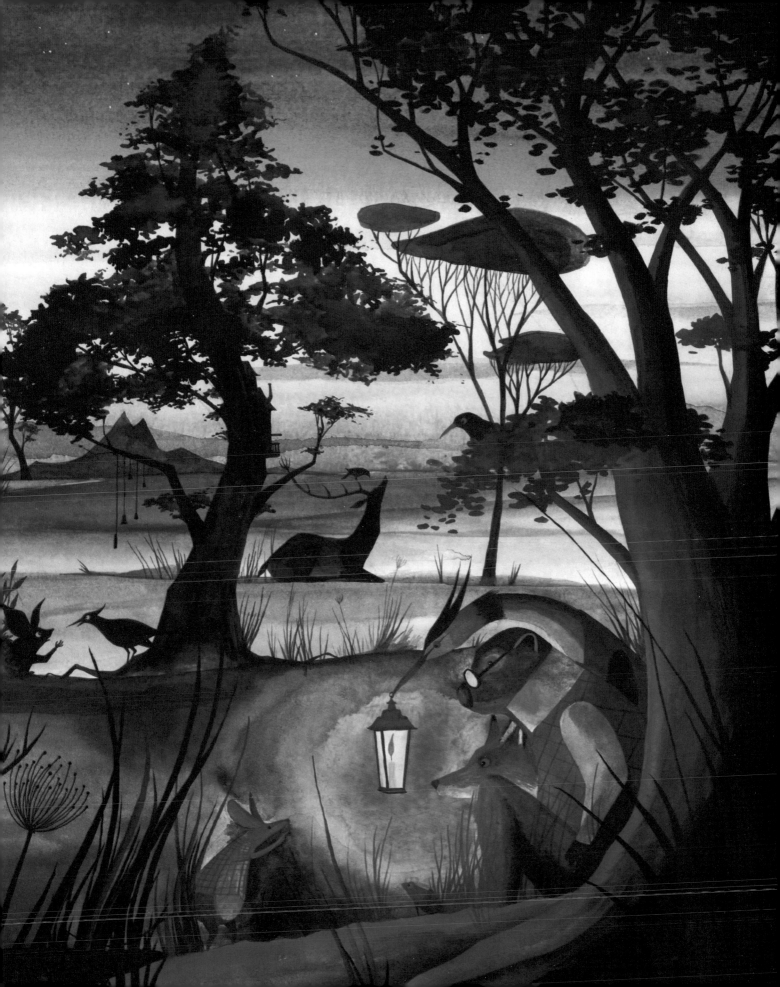

Todas las noches el viejo cartero se sienta
a la luz de una vela y escribe cartas. Las
cartas que va a repartir al día siguiente: citas,
invitaciones, disculpas, planes divertidos,
mensajes de amor...

Escribe y escribe hasta que, agotado, se
queda profundamente dormido sobre su
máquina de escribir.

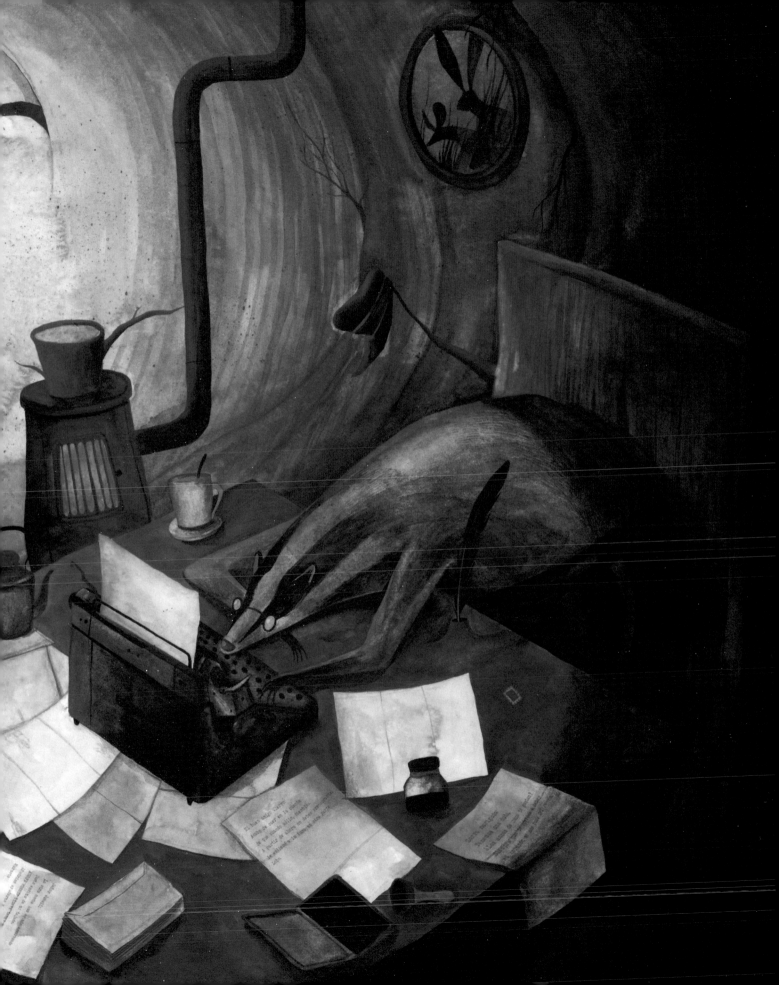

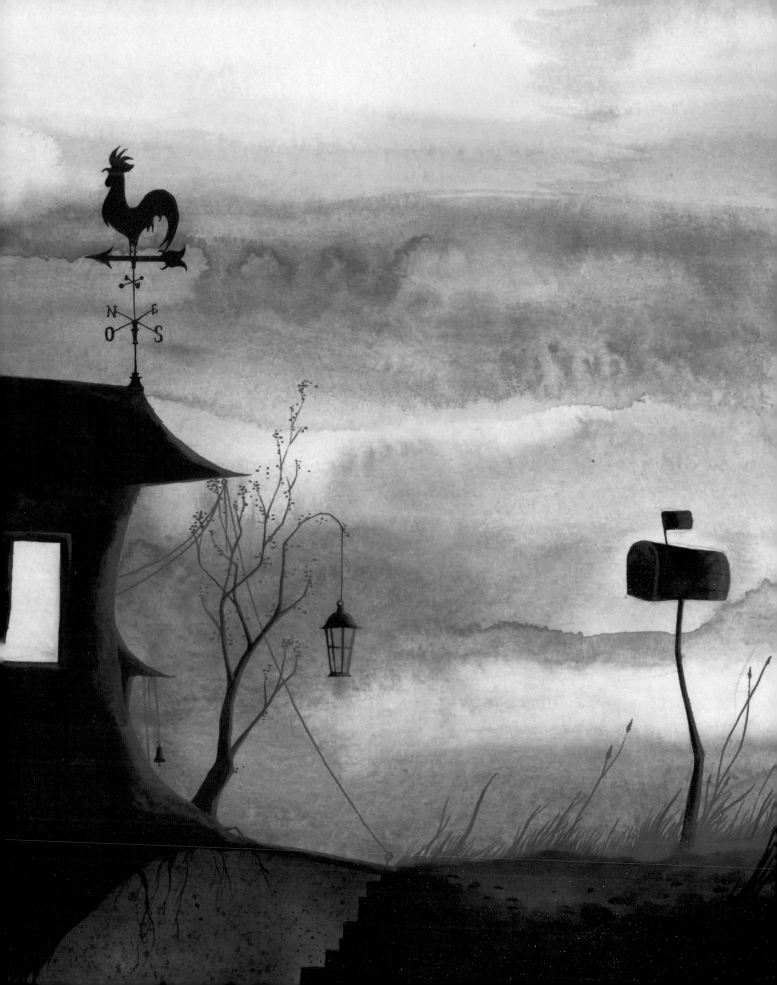

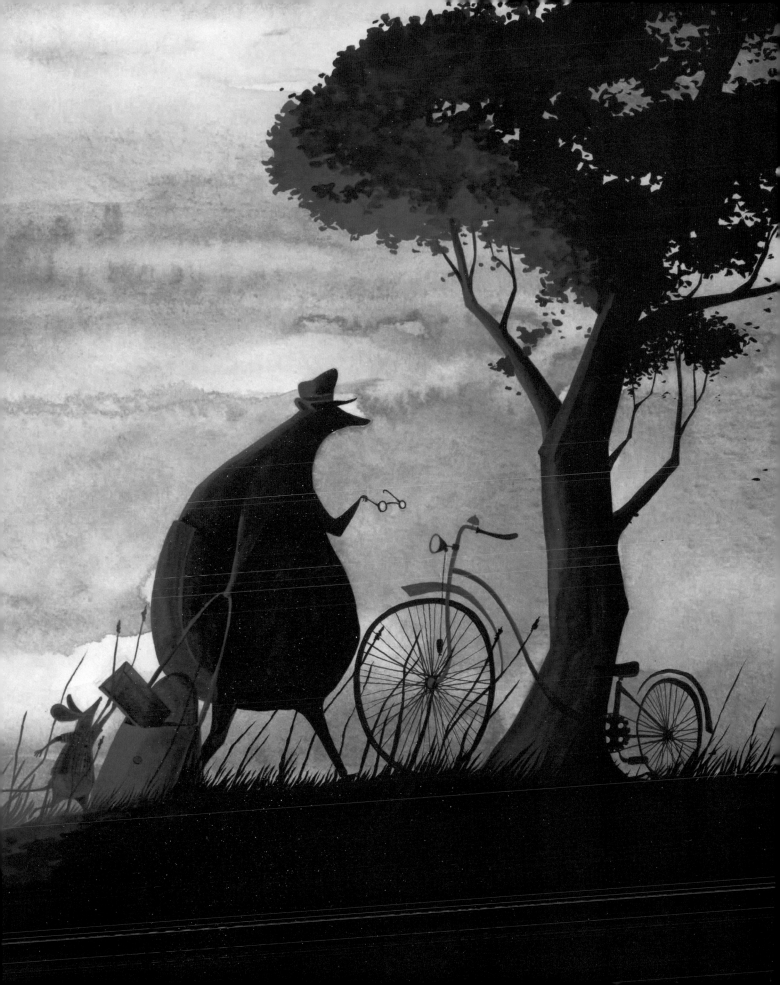

Un día, cuando el cartero está terminando de repartir todas las cartas, ocurre algo asombroso. La última lleva su nombre y su dirección escritos en el sobre.

¡Es una carta para él!

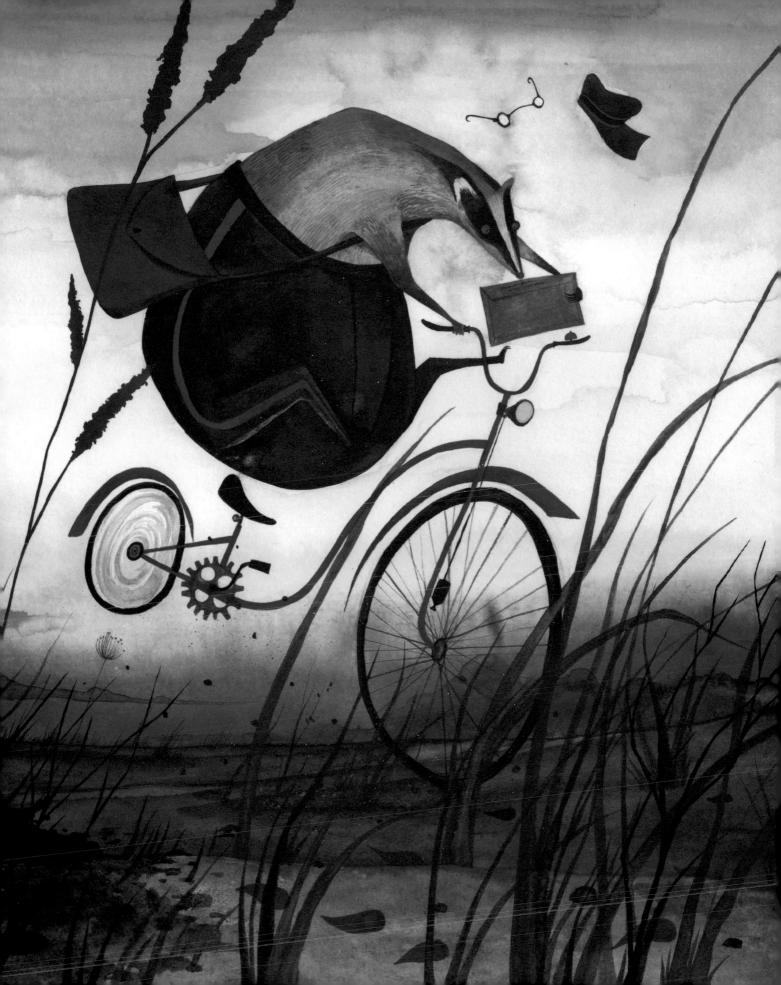

El cartero regresa a casa muy nervioso. Es la primera vez que recibe una carta. Cuando llega la introduce en el buzón y solo dice tres palabras:

—**Cartero, carta va.**

Después abre el buzón, toma la carta y entra a casa.

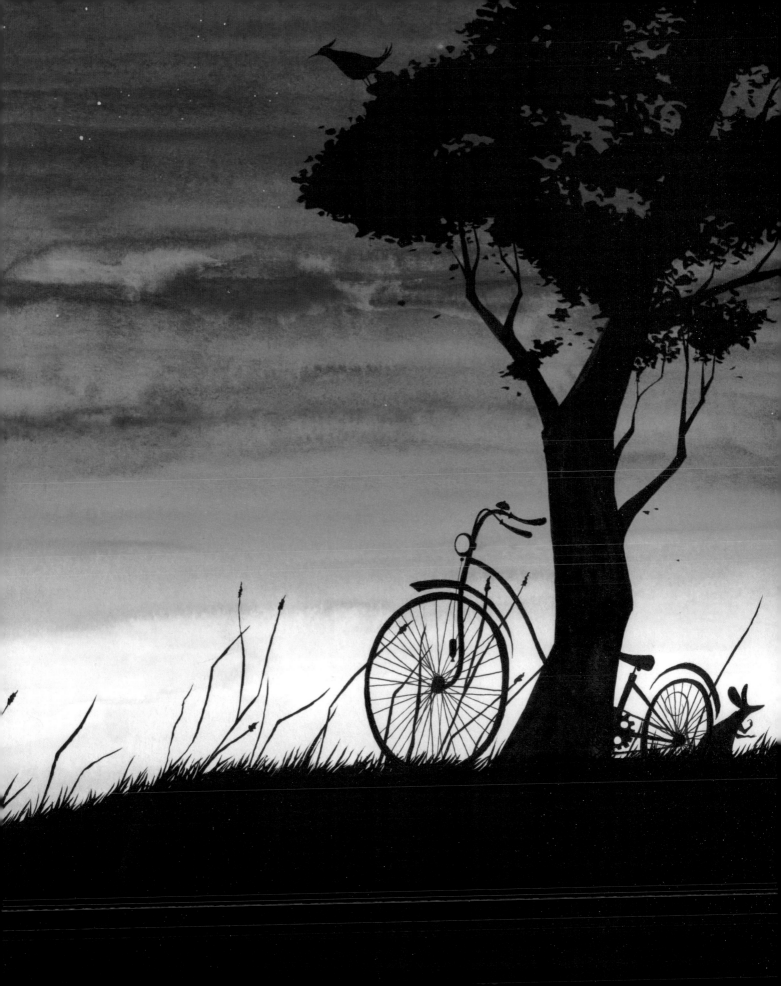

Amigo cartero,

Hace ya mucho tiempo que tus cartas llenan
nuestros días de ilusión y alegría.
Ahora por fin descubrimos tu secreto y
queremos darte las gracias por tantos buenos
momentos. Pero, sobre todo, queremos decirte
que estamos deseando compartir nuestra alegría
contigo.

 —Los animales del bosque

El viejo cartero tiene un fuerte nudo en la garganta y sus ojos se llenan de lágrimas.

De repente, suena el timbre. Su sonido está oxidado, también es la primera vez que alguien llama a su puerta.

Finalmente se arma de valor y la abre.
Fuera lo esperan todos los animales.
Al verlo, se abalanzan sobre él.

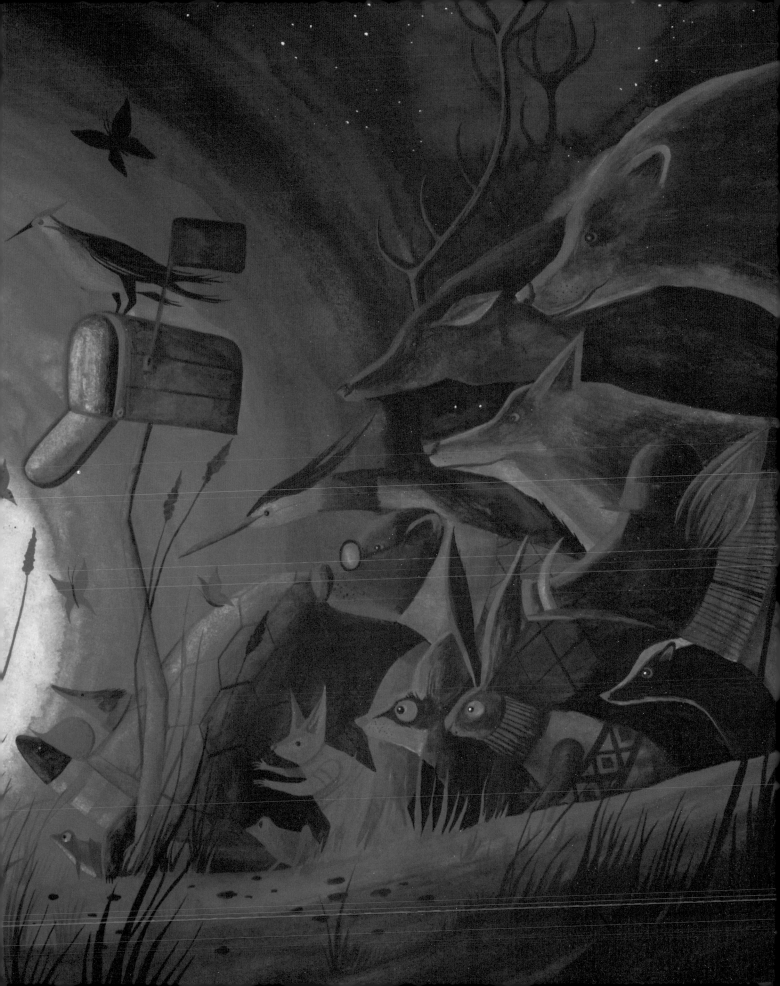

El viejo cartero sonríe colorado entre abrazos y halagos. Y mientras tanto ya está tramando las cartas que va a escribir de noche…

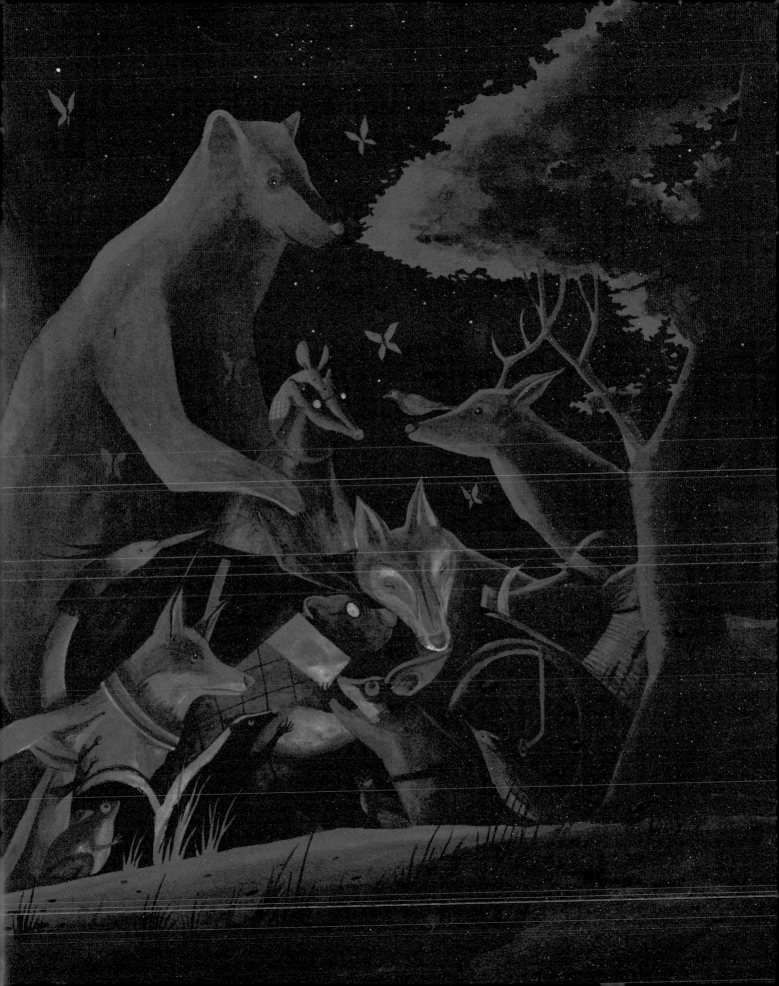

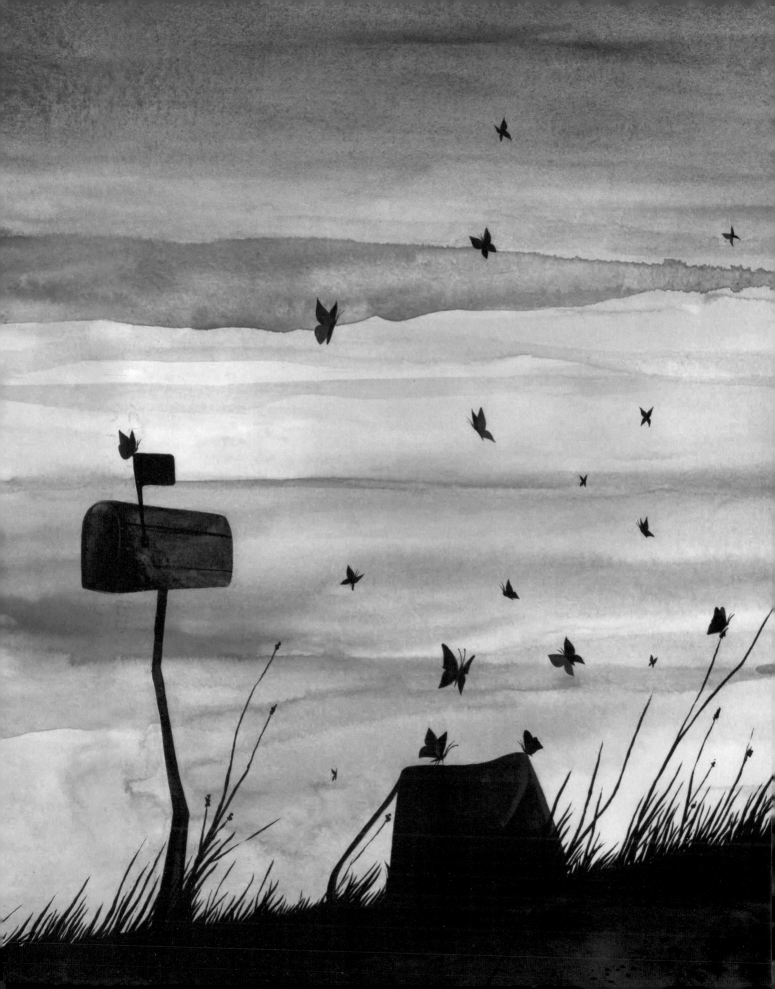